Painting Expressive Portraits *in* Oil

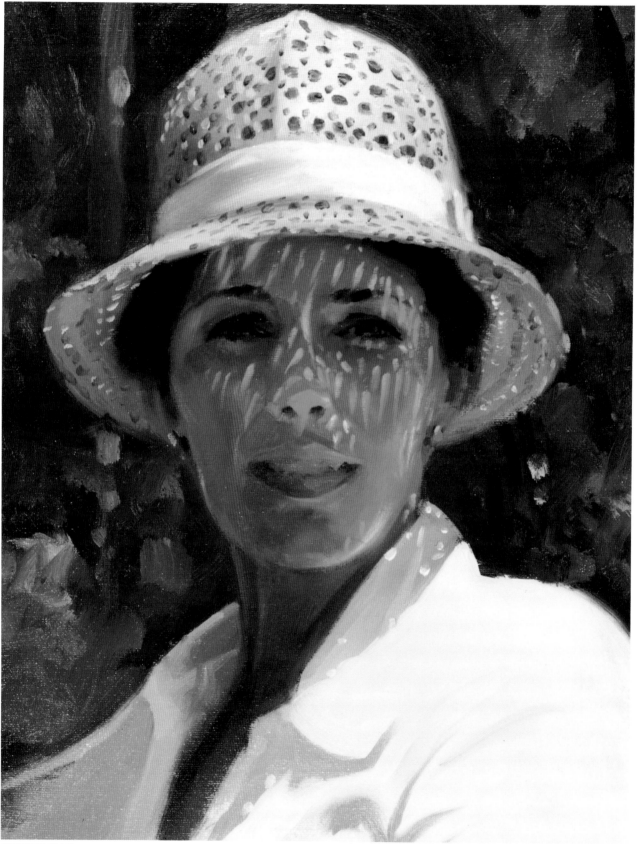

STRAW HAT

Painting Expressive Portraits
IN OIL

PAUL LEVEILLE

NORTH LIGHT BOOKS
CINCINNATI, OHIO

ABOUT THE AUTHOR

In his studio nestled in the hills of western Massachusetts, Paul Leveille paints the portraits of distinguished clients, both nationally and internationally. He has been pursuing his love of portraiture since 1980. Prior to that, he spent twelve years as an art director and illustrator in advertising. He is a graduate of the Vesper George School of Art in Boston.

In addition to his portrait commissions, Paul teaches portrait painting workshops and conducts portrait demonstrations around the country. He has also produced a 70-minute instructional video entitled *Portrait Demonstration in Oils* and is the author of *Drawing Expressive Portraits*, published by North Light Books.

Leveille is a member of the Copley Society, Boston; the Academic Art Association of Springfield, Massachusetts; the Springfield Art League; The Rockport Art Association, Rockport, Massachusetts; the Connecticut Pastel Society; the Oil Painters of America; the North Shore Art Association, Gloucester, Massachusetts; and the Pastel Society of America. He resides with his wife and daughter in West Holyoke, Massachusetts.

Painting Expressive Portraits in Oil. Copyright © 1997 by Paul Leveille. Printed and bound in China. All rights reserved. No part of this book may be reproduced in any form or by any electronic or mechanical means including information storage and retrieval systems without permission in writing from the publisher, except by a reviewer, who may quote brief passages in a review. Published by North Light Books, an imprint of F&W Publications, Inc., 1507 Dana Avenue, Cincinnati, Ohio 45207. (800) 289-0963. First edition.

Other fine North Light Books are available from your local bookstore, art supply store or direct from the publisher.

01 00 99 98 97 5 4 3 2 1

Library of Congress Cataloging-in-Publication Data

Leveille, Paul
 Painting expressive portraits in oil / by Paul Leveille.
 p. cm.
 Includes index.
 ISBN 0-89134-726-7 (hardcover : alk. paper)
 1. Portrait painting—Technique. I. Title.
ND1302.L44 1997
751.45' 42—DC21 96-37071
 CIP

Edited by Rachel Wolf and Jennifer Long
Production edited by Bob Beckstead
Cover designed by Brian Roeth

North Light Books are available for sales promotions, premiums and fund-raising use. Special editions or book excerpts can also be created to specification. For details, contact: Special Sales Manager, F&W Publications, 1507 Dana Avenue, Cincinnati, Ohio 45207.

ACKNOWLEDGMENTS

With most worthwhile projects, success usually depends on the efforts of more than one person. This book was no exception. I'm particularly grateful for the patience, encouragement and guidance given to me by my editors, Rachel Wolf and Jennifer Long. A special thanks to my generous mother-in-law, Mary Mitchell, for her endless hours of faultless typing from my barely legible longhand. My thanks also to photographers Neil and David Doherty for their outstanding work and continual support from the beginning of my career. And finally, many thanks to all the special people who allowed me to paint their beautiful faces.

TABLE OF CONTENTS

CHAPTER 4
Painting the Portrait
STEP BY STEP
41

•

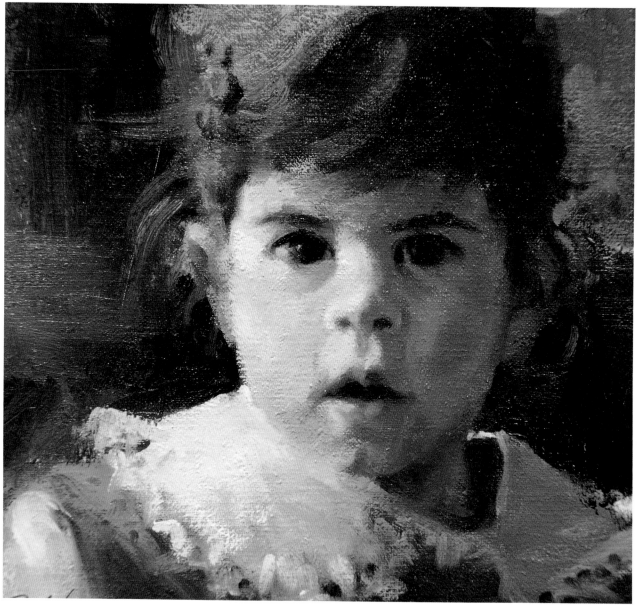

BETH
*This is an early painting I did of my
daughter when she was two. In it I worked
basically with dark and light patterns. I
think it is charming in its simplicity.*

When I first started to drive, I practiced on a standard shift car. I'll never forget the confusion I experienced trying to synchronize all the mechanical movements. It went something like this. To start, push in clutch with your left foot and shift to neutral. Turn key while lightly stepping on gas pedal with your right foot. Car starts—that's good. Now push the clutch in, move shift lever into first gear, let the clutch up, step on the gas lightly and with a few "bucks," we're off. (Don't forget to steer.) Next, while rolling, let off the gas and push in the clutch and move the shift lever into second gear, let up on the clutch, give it some gas—good. Oh-oh, a stop sign. Step on another pedal, the brake, softly. As you slow down, don't forget to push in the (buck-buck) clutch. And so it went.

But now, after lots of practice and experience, the last thing I think about while driving is the mechanics of the process. I'm free to think of where I'm going or what's for dinner.

Learning the painting process is very similar to learning how to drive a car. When you first start to paint—whether it's a landscape, still life or portrait—there are a lot of technical skills to learn such as mixing colors, seeing values, handling a brush and so on. Once you become familiar with these techniques through practice, you begin to think about them less. You start to grow. Getting the mechanical skills down allows you to be more creative, and allows you to exhibit more of your feelings in your paintings.

Getting back to learning how to drive: Even though it was confusing to me at the time, I loved every minute of it. I know that painting portraits can also be confusing. I hope this book will not only give you a better understanding of the painting process, but will also help to increase your enjoyment of the learning process.

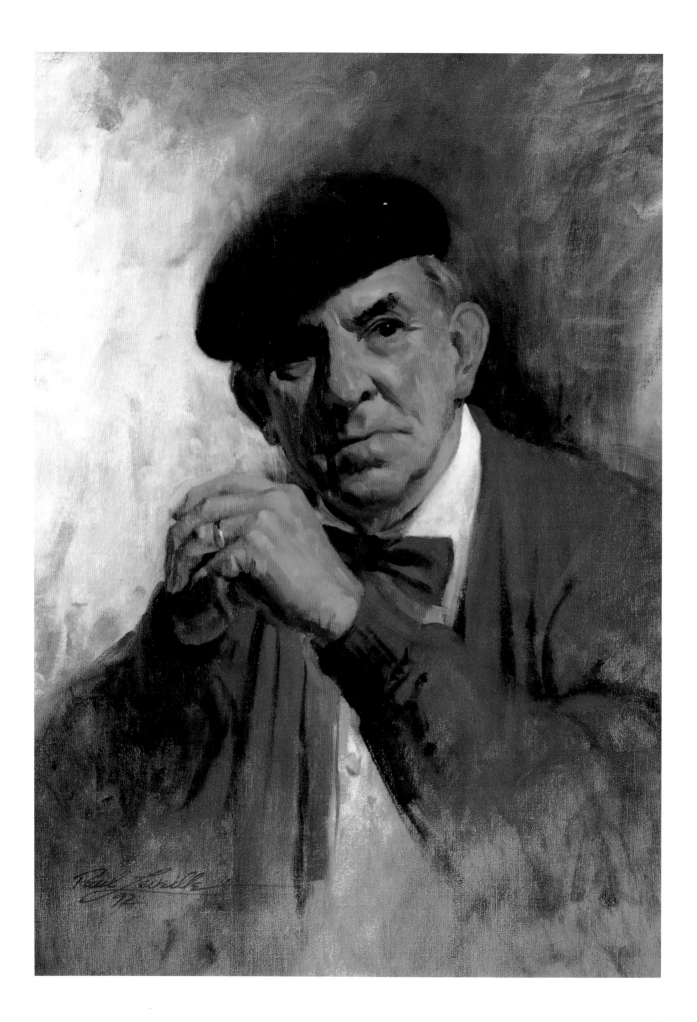

CHAPTER

1 Materials

Although practice, persistence and desire are important for successful outcomes in any occupation, hobby or sport activity, the importance of the equipment used in each endeavor cannot be overlooked. This is especially true in painting.

For example, it bothers me that beginner painting kits almost always contain the worst quality brushes. They are usually so small and stiff that even a pro would have difficulty using them, so imagine how discouraged first-time users might become if unknowingly they are trying to work with inadequate tools.

Even though the best materials may not guarantee you fame and glory as a successful artist, good equipment will make painting more enjoyable. If your painting time is enjoyable you will want to paint more, and the more you paint, the better you will become at it.

THE BLACK BERET
The dominating red of this model's sweater intrigued me. However, I did not want the color isolated to just the sweater. So I spread a red wash from the sweater up into the background to create an interesting design early on in the painting. I also wanted the model's strong hands to tie in with his face. Everything else fades into the background.

Basic Materials

OILS

For years I've used Rembrandt oils and have been very pleased with them. In addition, I use Permalba White because I like its smooth, buttery consistency. My palette arrangement is as follows:

Permalba White
Cadmium Red Light
Cadmium Orange
Cadmium Yellow Light
Yellow Ochre
Raw Sienna
Raw Umber
Burnt Sienna
Venetian Red
Indian Red
Burnt Umber
Alizarin Crimson
Ultramarine Blue
Cerulean Blue
Permanent Green Light
Viridian
Ivory Black

BRUSHES

My preferences for brushes are hog hair filberts. I use Robert Simon's and Utrecht no. 209 series. My smallest filbert is a no. 4 and my largest is a no. 12. I enjoy the versatility of filberts: Using the broad side of the almond-shaped brush will leave a wide stroke, while turning the brush on its edge achieves a very thin line. I also have some 2-inch (5.1cm) flats for large background areas. Several sizes of fan brushes—used primarily for finishing hair—complete the list.

PALETTE

A white glass surface is my preference. In the studio I have a large 18″ × 47″ (45.7cm × 119.4cm) piece of white ¼-inch (.6cm) thick glass. It is mounted on a chest of drawers at an angle to prevent glare.

When traveling, I use a 20″ × 24″ (50.8cm × 61cm) piece of Plexiglas. A piece of white foamcore is taped under it to give me the white surface that I like. It's easy to clean and light to carry.

CANVAS

Prestretched cotton or linen canvases are available in various sizes. These prestretched canvases are usually primed with acrylic gesso, for oil or acrylic use. Oil- or acrylic-primed cotton and linen canvas are also available in rolls. The advantage to using rolled canvas is that you can cut the canvas to the exact size you desire and stretch it on wooden stretcher strips, which come in various lengths.

For finished work, I prefer to use a linen canvas that is oil primed. At present I use Utrecht-Claessens no. 850 Belgian linen, because I like the texture and the weight of this canvas. For less formal work, I enjoy the tooth and texture of several brands of prestretched canvases.

Another economical surface is canvas board. This product consists of cotton canvas that has been glued to a dense paper board. It comes in many sizes, is stiff, and is great for traveling since it takes up little space and is lightweight.

STRETCHERS

Standard stretchers are wood strips about 1⅝″ × ¾″ (4.1cm × 1.9cm) that come in a variety of lengths. The ends of these strips interlock to form a rectangle or square frame. Once you assemble a stretcher frame to the size you desire, you can then stretch a piece of canvas over it. Add three inches (7.6cm) to both the height and width of your stretcher bar frame when cutting your canvas, as it will be fastened over the outside edges of the frame.

STRETCHING A CANVAS

Assemble the stretcher strip frame. Corners can be squared up quickly by laying your frame on a full sheet of mat board and aligning the side and bottom of your frame with the edges of the board. (Check for accuracy by measuring from one corner of the frame to the corner diagonally opposite. This measurement will be the same for both diagonals when your frame is squared.) Staple each corner over the joints to prevent the frame from shifting as you stretch the canvas.

Next, lay the canvas face-up over the frame. Staple the center of one end of the canvas to the center outside edge of the frame. Now pull the canvas tightly across the frame opposite the stapled side. When you see a vertical crease form in the canvas, staple this side to the center outside of the frame. Next, take one of the remaining unstapled sides and stretch and staple it in the center. Do the same with the last unstapled side. This should create a diamond crease pattern in the canvas.

Now go back to your first side and pull the canvas taut. Add another staple at a point about 2″ (5.1cm) to the right of the center staple. Repeat to the left of the center staple. Continue this process on the remaining three sides. Now move around the frame pulling the canvas tight and stapling until you've secured the entire canvas. Fold the corners over and staple the folds to the back of the stretcher frame, as shown below. Now you're ready to paint.

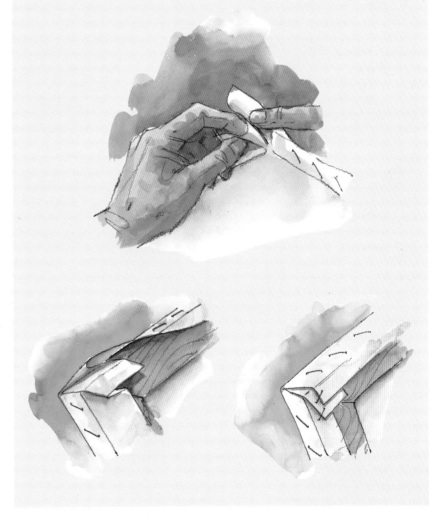

Additional Supplies

CHARCOAL

Medium-grade vine charcoal is what I use most often for preliminary drawings on canvas. It goes on smoothly, can be sharpened to a point on a sandpaper block, and is easy to remove with a cloth or eraser. I also use 2B charcoal pencils for some preliminary work on canvas. This pencil is harder than vine charcoal and is good for detail work.

PALETTE KNIFE

Although I don't use a palette knife for painting, it is an invaluable tool for moving piles of color on the palette. It can also be used to scrape off unsuccessful strokes on the canvas.

SANDPAPER BLOCK

To sharpen a piece of vine charcoal, press the tip against a sandpaper block and roll the stick between your fingers—you can achieve a very fine point this way. You can buy a sandpaper block, or make one by cutting a few sheets of fine grit sandpaper into 1″ × 6″ (2.5cm × 15.2cm) strips. Stack about six strips together and staple them at one end to a 2″ × 7″ (5.1cm × 17.8cm) piece of board. When the top strip of sandpaper is full of charcoal and has lost its tooth, tear it off to reveal a fresh strip underneath.

PALETTE SCRAPER

A retractable house painter's scraper—found at hardware and paint stores—is ideal for cleaning glass palettes. These scrapers are economical, small enough to fit in your hand, and the double-edge razor blade is replaceable.

MEDIUMS

A mixture of one part damar varnish, one part stand oil and four parts turpentine is a standard medium that I have been using for quite a while. When a little is mixed with paint it produces a buttery consistency.

MEDIUM CUPS

These metal cups that come in various sizes and attach to the side of your palette are indispensable for holding mediums. I use two. One holds turpentine, which I use for washes on my canvas and for cleaning my palette. The second cup holds my painting medium.

TURPENTINE

I use pure gum turps for mixing with medium, for cleanups and for large washes on my canvas.

TURPENOID

Because this thinner is odorless, it's ideal for cleaning brushes in the studio.

WORKABLE FIXATIVE

After sketching with charcoal on my canvas, I remove the excess dust by tapping the canvas with my finger. Next, I spray the canvas with Blair workable fixative. (I do this outside, since the fumes can be harmful.) Fixative prevents the charcoal from smudging with the paint later on.

RETOUCH VARNISH

During the painting process, some dull areas may appear. A light spray of retouch varnish will bring the area back to its original vibrancy.

FINAL VARNISH

When a painting is completed, I give it a light spray of matte finish varnish. This varnish gives the painting an overall matte (nonglossy) finish that I like. It also protects the painting and makes it easier to clean in the future, if necessary. (Pay close attention to manufacturer's warnings about proper ventilation when using any type of aerosol fixative or varnish.)

RUBBER GLOVES

Since I paint every day, I have to clean brushes and palette many times every day. When cleaning, I always wear rubber gloves to protect my hands from solvents.

MIRROR

To gain a fresh perspective on your work, view it in a mirror. Mistakes that have been overlooked will suddenly jump out at you. In my studio a large mirror hangs on a door opposite my easel. To check my painting I just turn to the mirror and can immediately get a new angle on my values, drawing and design. In addition, the mirror doubles the distance between you and the painting, so you see the overall painting, not just the details.

PAPER TOWELS

I have a roll conveniently attached to the side of my taboret, which I use primarily for cleaning my brushes and palette.

BRUSH TRAY

It's not unusual for me to use twenty to thirty brushes during a painting session. I like to use a clean brush for each value and color, as well as different size brushes for various passages. Where do I put all these brushes while painting? I simply cut V notches into the top of each of the long sides of a sturdy cardboard shoe box, as shown. The notches keep my brushes separated and prevent them from rolling away while I'm working, and allow the brushes to air dry overnight after washing. Plus, I simply dump all my brushes into the box when I'm finished painting to carry them to and from the sink for cleanup.

MAKING A BRUSH BASIN

Once you've enjoyed your favorite brew down "to the last drop," save the empty can. It will make an excellent cleaning container for your brushes. To build the cleaning container, wash out the coffee can. Next, take a clean tuna can (or any other can that is smaller in height and width than the coffee can), turn it over and punch holes in the bottom with an awl or a hammer and nail. Put in as many holes as you can. Now drop the smaller can upside down into the coffee can. Next, fill the coffee can about two-thirds full with odorless thinner. Now you can clean a dirty brush by sticking it into the thinner and rubbing the bristles on the bottom of the smaller, submerged can. The oil paint from the brush will fall through the holes in the smaller can and settle on the bottom of the coffee can. Keep swishing the brush until it is clean, then wipe it dry with a paper towel.

The Studio

The hardest part of any endeavor is starting. Painting is no exception. Consider this scenario. You've just completed your work for the day and you have a few minutes to yourself. You think, "Gee, I'd like to do a little painting now." However, your next thought is "Let's see, the last time I saw my paints they were packed away in the cellar. I'll have to get my easel from the garage . . . Did I clean my brushes the last time I used them? Oh, and the kitchen table will have to be cleared. On second thought, I think I'll paint another day." Sound familiar?

One way to eliminate this start-up problem is to find a small space somewhere in your home that is private, where you can leave your painting material set up. It may be your spare room or part of the attic or cellar, as long as it's large enough to hold an easel and a taboret. That way, the next time you have the urge to paint, you can walk to your "studio," turn on the light and *start* painting. Once you start, you are over the hardest hurdle, and you may find that the next hurdle will be how to *stop* painting.

CAMERA

A good 35mm camera is very important. First, it's handy for photographing the model so you will have a reference to paint from when the model is not available to sit. Second, it's a good idea to duplicate your work in slides and prints. That way you will have a photographic record of your work for safekeeping, and will have slides on hand if you decide to enter a show or competition (the judges almost always want slide entries).

LIGHTS

A 150-watt bulb that screws into an aluminum clipshade is ideal for lighting models. Color-corrected fluorescent bulbs that approximate daylight are necessary for seeing accurate colors on your palette and canvas. Check with your lighting dealers for these bulbs.

TABORET

A table, usually with drawers, that can hold a palette, brushes, paint and any other items that you will need quick access to as you are painting.

EASEL

There are many easels on the market to choose from—from economical aluminum easels to very expensive wood studio easels. As with any purchase, consider your needs. You will need an easel that is sturdy and one that will hold the size paintings you intend to work on.

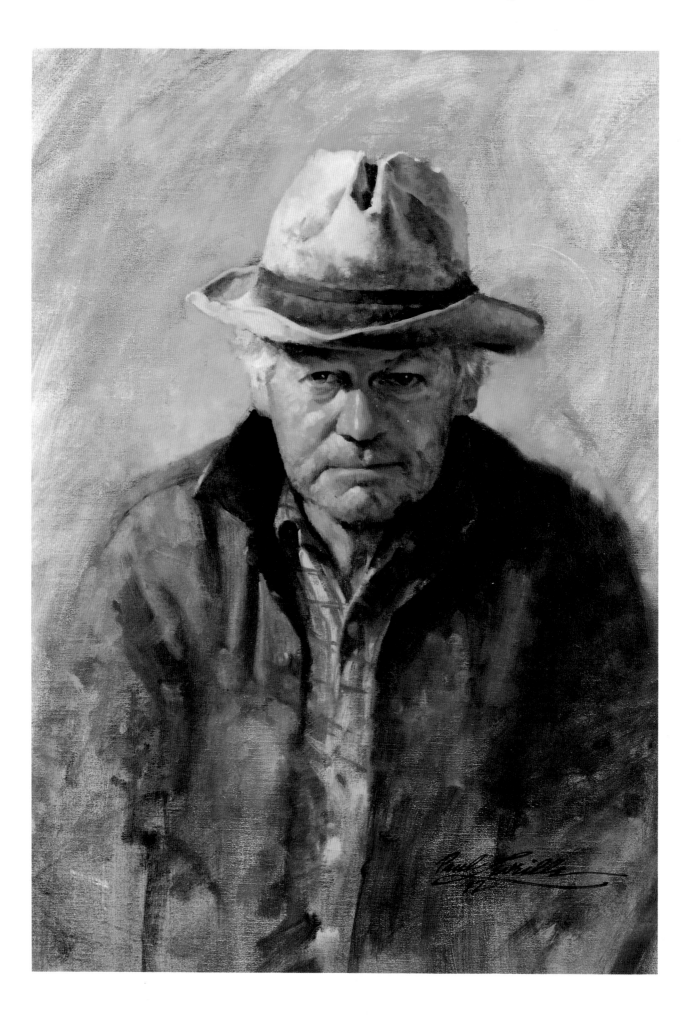

2 Painting the Features

One of the most fascinating aspects of the human head is that even though each head contains the same features (eyes, nose, ears, mouth, etc.), no two heads are alike. The variation in feature sizes, colors, shapes and placements allows for an unlimited number of different looking heads. Perhaps that is why I never get bored with painting people.

In this chapter, we will first learn about the location and relationship of the features that make up the human head. I'll also show you how to maintain those feature relationships in your painting, no matter what position the head is in. The remainder of the chapter will show a step-by-step method of building each feature.

THE HOBO
Once again I have created a design in the portrait through large color patterns. For example, I moved the blue of the jacket into the background as well as into the face. Notice even the yellow background reappears in the shirt.

Placing the Features

Even though each head is different, these guidelines will give you an approximate location of the features on every human head.

A Using a vertical line to divide the head, notice that the eyes are about one eye width apart. The nose and lips are divided evenly along this vertical line.

B The top of the ears are in line with the bottom of the eyebrows.

C The eyes are located halfway between the top of the head and the chin.

D The bottom of the nose falls halfway between the eyebrows and the chin. The bottom of the ears sit on line with the bottom of the nose.

E The bottom of the lower lip touches halfway between the nose and chin.

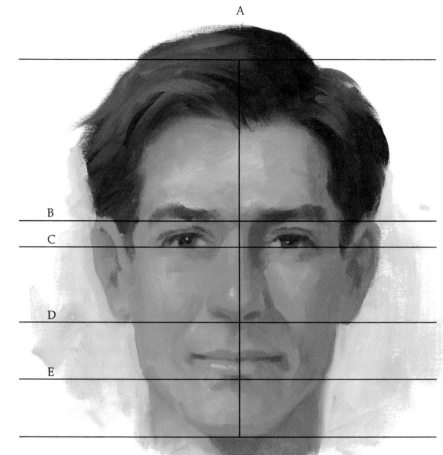

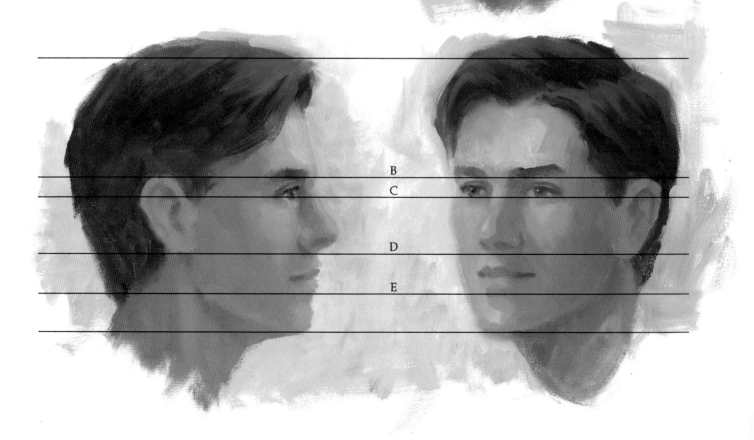

Tilting the Head

Here is a suggestion to help you understand how the location of the features will appear when the head is tilted. Turn a paper cup upside down and draw a horizontal line around the center. Draw the remaining feature guide lines as seen on the previous page. Now draw in the eyes, bottom of the nose, ears and lips in the appropriate locations on the cup. When you view the cup in various positions, you will be able to see how the features relate to each other.

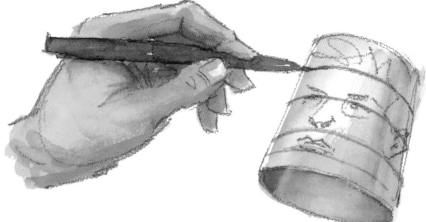

In this sketch the head is tipped back. By tipping the cup back in the same position, you will find the features you've drawn on the cup relate to each other just as they do in the sketch. If you lay a pencil on this sketch under the ear in a horizontal position, you will notice that it intersects the bottom of the lower lip.

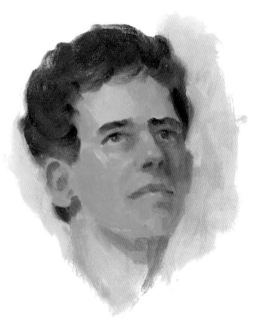

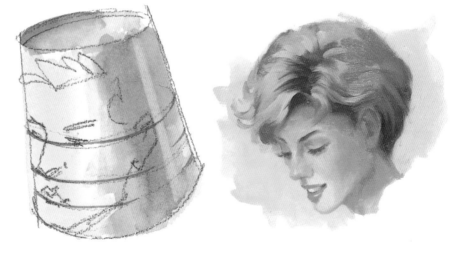

As you can see, the head in this sketch is tilted down. Try laying your pencil on this sketch as you did in the previous one. Notice when you line the pencil up under the ear that it now intersects under the eyes.

The Eyes

The eyes are usually the focal point in a portrait. They, along with the eyebrows, will reveal the mood of your subject more than any other feature. The movement of the eye itself, as well as the muscles around it, allow for a variety of expressions. Very often I am asked, "How can I capture that expression? The sparkle? The twinkle?" "How can I paint that eye so it appears to be real?" In the following demonstration, I will answer these questions by illustrating how I approach the construction of an eye, and bring it to completion.

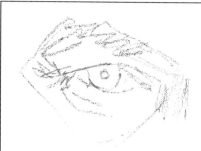

1 *Using an HB charcoal pencil, lightly sketch in the eye on white canvas. Once you're satisfied with the sketch, give it a light spray of Blair workable fixative. This will prevent the charcoal from smudging or mixing with the paint.*

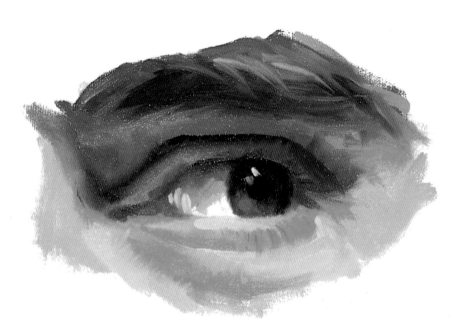

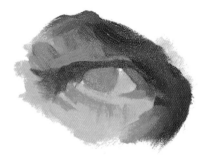

5 *At this point I want to add a basic color and shape for the iris. Using a clean brush, mix Raw Umber, Permanent Green Light, Yellow Ochre and white to paint the iris. Paint the eyebrow area with a mix of Raw Umber and Yellow Ochre.*

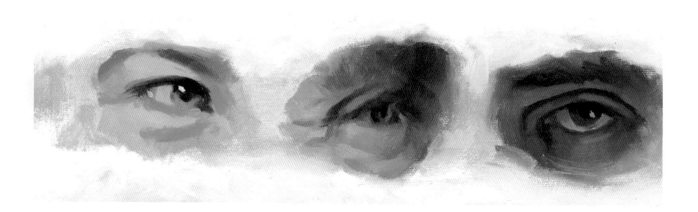

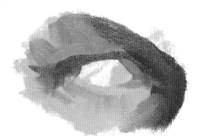

 2 There won't be any solid white showing on the final painting, so the next step is to add a light skin tone over the entire area. For this skin tone, mix Cadmium Red Light, Yellow Ochre and lots of white. Notice how I've scumbled the paint on with my brush very lightly. You can still see the drawing through it.

3 Next, start building the halftone areas around the eye. These halftones are a little darker in value than the light areas. Paint these areas with a mixture of Cadmium Red Light, Raw Sienna and white.

4 By squinting at the model, I determine the shape of the darkest value areas. With a clean brush, mix Venetian Red, Ultramarine Blue, a little Cadmium Red Light, and a touch of white for these areas.

As the forms turn toward the light, the colors get warmer as well as lighter. To achieve these warmer colors, add Cadmium Red, Yellow Ochre, and a little white to the previous mixture.

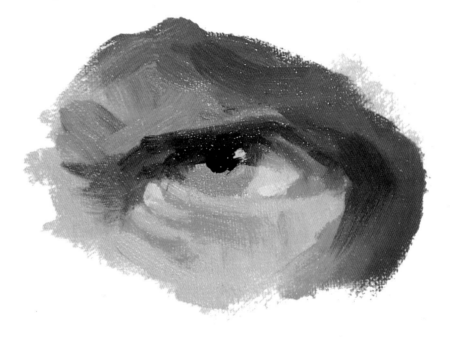

6 A shadow from the eyelid appears on the upper part of the iris. Paint this in with Burnt Umber. You will also use this color along the lash area of the upper lid. A rich dark is added to the right of the eye in the shadow area.

Using a no. 4 brush with a good point on it, mix a very light skin tone, and add the highlight on the eye. Notice that it is positioned at a spot where it touches both the iris and the pupil.

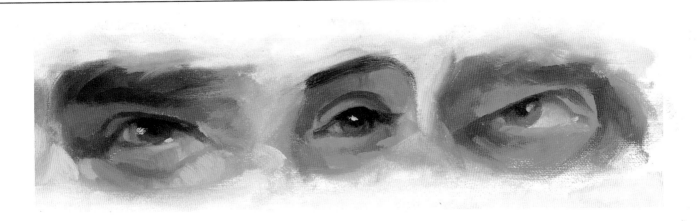

The Nose

One of the most prominent features of the human head is the nose. Because of the way it protrudes, it is often seen one side in light while the other side is in shadow. This makes for an excellent example of how to construct a feature by painting the big shapes (lights and darks) first. The following demonstration will explain the step-by-step process.

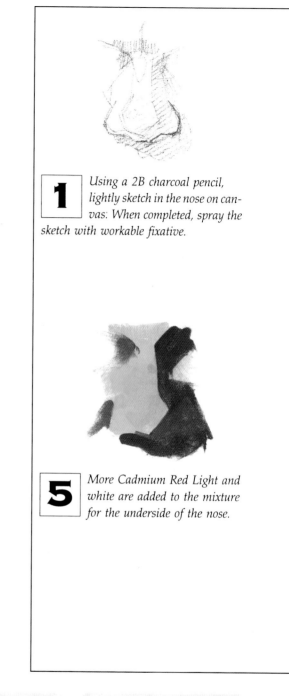

1 *Using a 2B charcoal pencil, lightly sketch in the nose on canvas: When completed, spray the sketch with workable fixative.*

5 *More Cadmium Red Light and white are added to the mixture for the underside of the nose.*

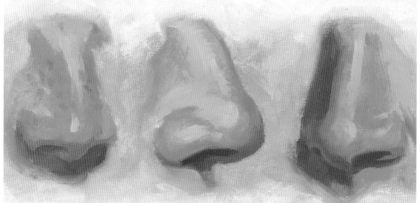

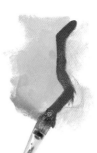

 Since there is no solid white on the model's nose, we want to get rid of the white on the canvas. Mix Cadmium Red Light, Yellow Ochre and white. This mix is lightly scumbled over the drawing with the side of the brush.

3 For the warm halftones, use the same skin mixture with a little more Cadmium Red and Yellow Ochre added. Paint this mixture on the bridge of the nose and on the wing of the nostril on the light side of the nose.

4 By squinting at the model, I see the shadow side of the nose as one dark shape. To paint this shape, use a mix of Indian Red, Ultramarine Blue, a little Cadmium Red Light, and a touch of white (just enough to see the color of the mixture). Start with a bold stroke down the side of the nose.

 At this stage I want the area between light and dark to become rounded, so I need to add a halftone. Mix Cadmium Red Light, Raw Sienna and white. Apply this color with your brush between the dark and light shapes along the bridge and the bulb of the nose. You can also use this mixture for reflected light under the nose and on the wing of the nostril lying on the shadow side of the nose.

7 Mixing Cadmium Red Light, Yellow Ochre and white with your brush, paint some warm tones along the light side of the bulb of the nose and the bridge. Add more Yellow Ochre and white for the lighter areas of the bulb and bridge.

8 Using the tip of a no. 4 brush, add highlights to the bridge and the end of the nose. The highlights are a mix of Cadmium Red Light, Cadmium Yellow Light and lots of white.

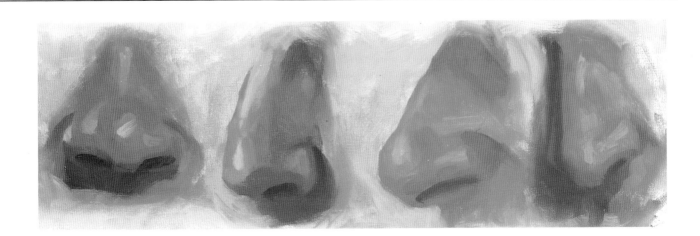

The Lips

They move, they stretch, they pucker. The lips are one of the most animated features of the human head. The important thing to keep in mind is that the lips are part of the muscles that form the muzzle area of the face. For this reason, it is necessary to paint the forms around the lips first. The following demonstration is a good example of this approach.

1 Start with a sketch using a 2B charcoal pencil on white canvas. A light spray of workable fixative is used after the sketch is completed.

5 Paint the light areas of the lips with a mixture of Cadmium Red Light, Yellow Ochre and white. Here I also reaffirmed the dark areas of the lips and increased the darkness of the values of the skin on each side of the mouth.

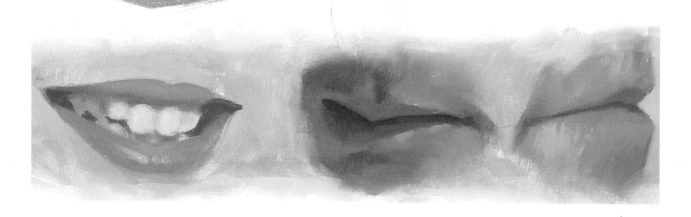

2 *Scumble a light mixture of Cadmium Red Light, Cadmium Yellow Light and white over the sketch and around the lip area with the side of your brush.*

3 *Next, build the area around the lips. The darker areas are painted with Cadmium Red Light, Yellow Ochre, Permanent Green Light and white. For the lighter values, use Cadmium Red Light, Cadmium Yellow Light and white.*

4 *By squinting at the model, I have simplified the shape of the darkest area of the lips—paint this with a mix of Cadmium Red Light, Raw Umber and white. Mix a middle value color of Cadmium Red Light, Yellow Ochre and white and paint the middle tones.*

6 *At this point, add the darks between the lips with a nicely pointed no. 4 brush. Notice how I vary the stroke and weight of this line for a more natural look. Use a mix of Burnt Umber, Cadmium Red Light and white.*
Finally, add the highlights with a mix of Cadmium Red Light, Yellow Ochre and lots of white. Paint a touch of a light lip mixture at the top of the lips to soften the transition to the skin.

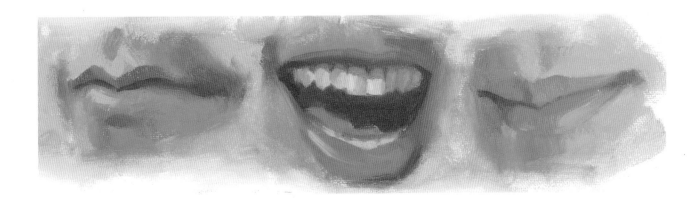

The Ears

Those wonderful hearing devices attached to the sides of our heads sometimes appear to be a complicated mix of folds and dips and curves. The best way to approach painting ears is to keep it simple. Look at the overall shape. Then break that shape down into simple dark and light shapes. The following demonstration will help you master this approach.

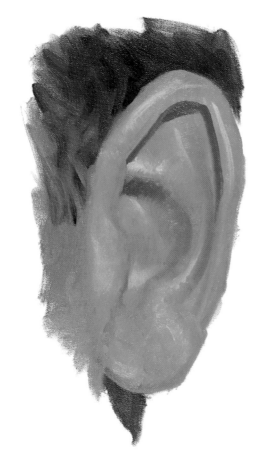

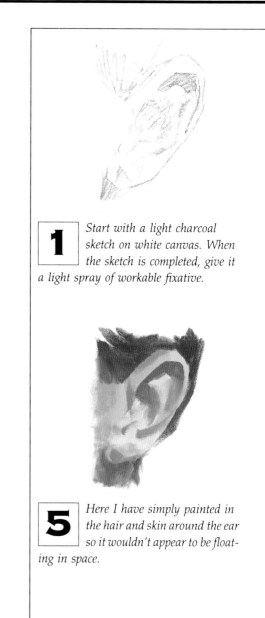

1 *Start with a light charcoal sketch on white canvas. When the sketch is completed, give it a light spray of workable fixative.*

5 *Here I have simply painted in the hair and skin around the ear so it wouldn't appear to be floating in space.*

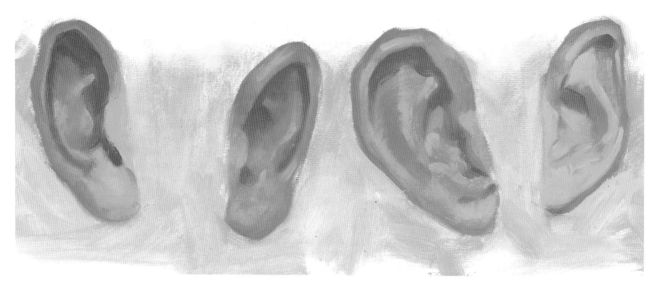

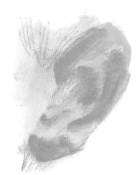
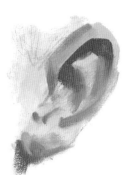

 To eliminate the white canvas, use the side of your brush to scumble on a light skin tone made up of Cadmium Red Light, Yellow Ochre and white.

3 Next, look for the big halftone areas—those shapes between dark and light—and paint them in with a mix of Yellow Ochre, Alizarin Crimson and white.

4 Squinting at the model, determine the shapes of the dark areas of the ear. Using a mix of Venetian Red, Ultramarine Blue, Cadmium Red Light and a touch of white, paint the dark areas in. As the form turns from dark to light, add Cadmium Orange to the mix.

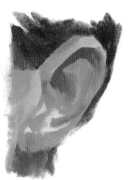
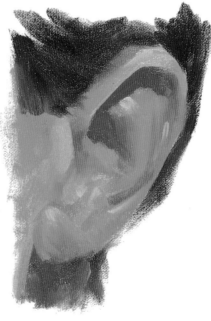

6 Now paint the smaller value and color areas within the large dark and light shapes. For the shapes in the light areas, use Burnt Sienna, Cadmium Red Light, Yellow Ochre and white. For the warm dark areas (such as the bowl of the ear), use a mix of Venetian Red, Cadmium Orange and white.

7 Now define the lightest areas with Cadmium Yellow Light, Cadmium Red Light and white. Finally, using a no. 4 brush, add the highlights using the above mixture with more white added.

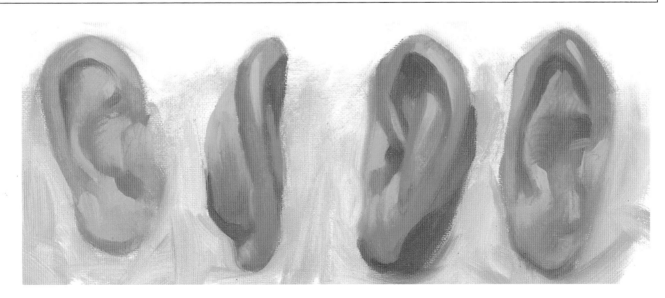

The Hair

What other feature can wear so many hats? (No pun intended!) Hair comes in many colors and textures, and a variety of lengths. And don't forget beards and mustaches. Once again, simplicity in approach is the key to painting believable hair.

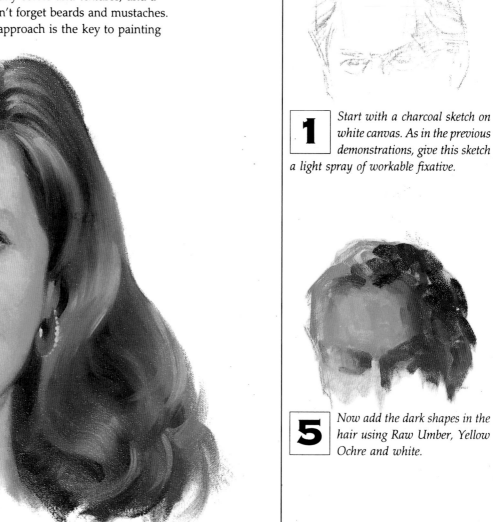

1 *Start with a charcoal sketch on white canvas. As in the previous demonstrations, give this sketch a light spray of workable fixative.*

5 *Now add the dark shapes in the hair using Raw Umber, Yellow Ochre and white.*

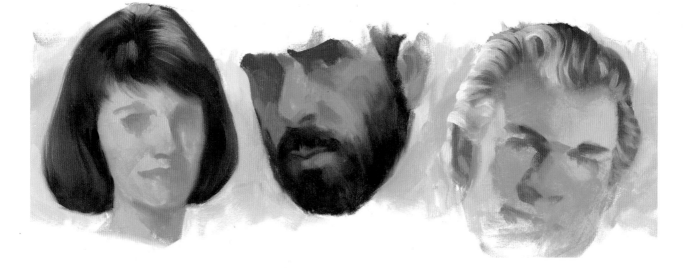

2 Since hair grows out of the skin, it is necessary to add a skin tone not only to the face, but over the hair as well. With the side of your brush, scumble a mix of Cadmium Red Light, Yellow Ochre and white.

3 Paint the middle value areas of the hair with a mix of Raw Umber, Yellow Ochre and white.

4 It is important to shape the forehead and temple areas in order for the hairline to blend naturally in those areas. Start by painting in the darks with Venetian Red, Ultramarine Blue, Cadmium Red and a touch of white.

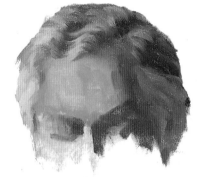

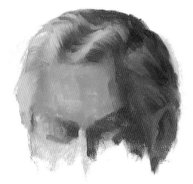

6 For the light areas of hair on the shadow side of the head, use Raw Umber, Raw Sienna and white. Be careful not to make this color too light, as it is still in the shadows and not receiving as much light as the light side of the head.

7 For the light areas of hair on the light side of the head, use Raw Umber, Yellow Ochre and more white. For some of the warmer areas, add a touch of Burnt Sienna to the mix.

8 A very light mix of Raw Umber, Yellow Ochre and lots of white is used for the highlights. Notice how I keep my brushstrokes moving in the direction of the hair for a more natural appearance.

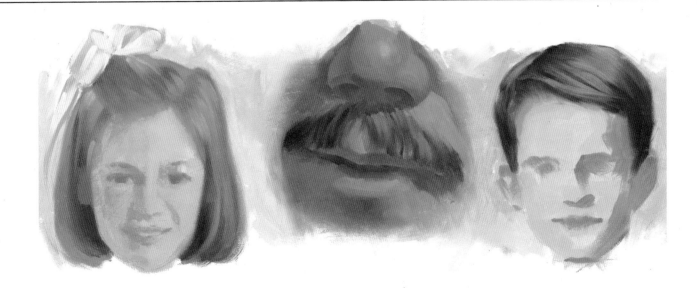

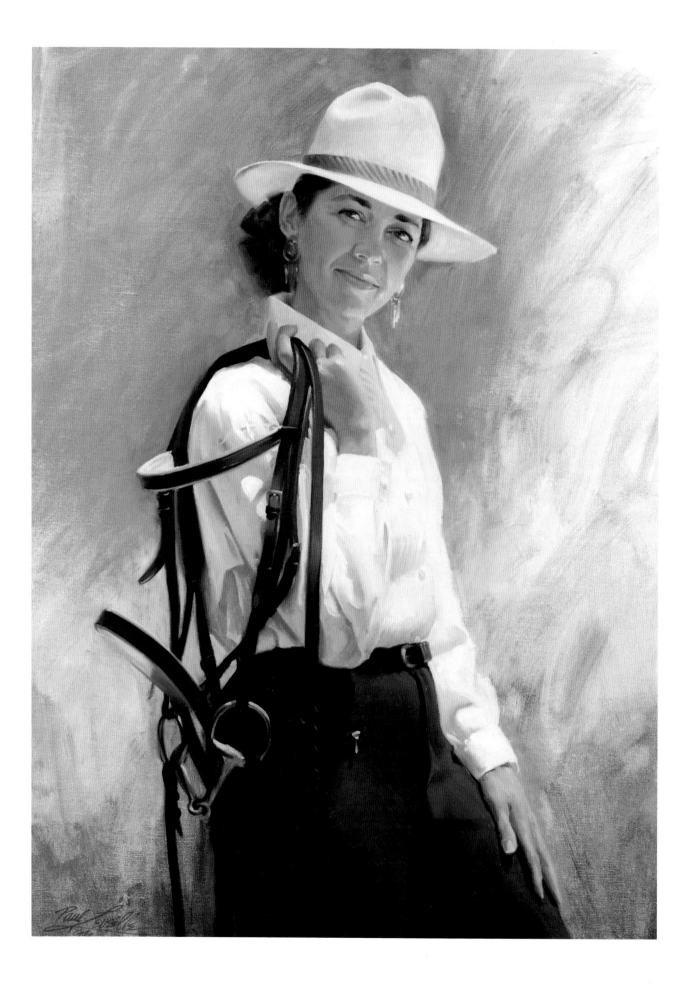

3 Values and Color Mixes

Values define the degrees of lightness or darkness of a form. The darkness or lightness of a form is determined in one of two ways—by how much or how little light is hitting it, or by its natural color. For example, envision a white house with a black roof on a sunny morning. The shadow side of the house is much darker than the side in full sunlight. However, the black roof, even though it is receiving direct sun, is much darker than the shadow side of the white house.

In nature, there are hundreds of different values that make up various forms. To simplify the value-identifying process, artists usually break the value scale into ten degrees. These degrees run from solid black, progressively getting lighter until they reach white. In this chapter, you will see how a value scale can help you mix the right color and value to paint a solid-looking head.

Value Scale Exercises

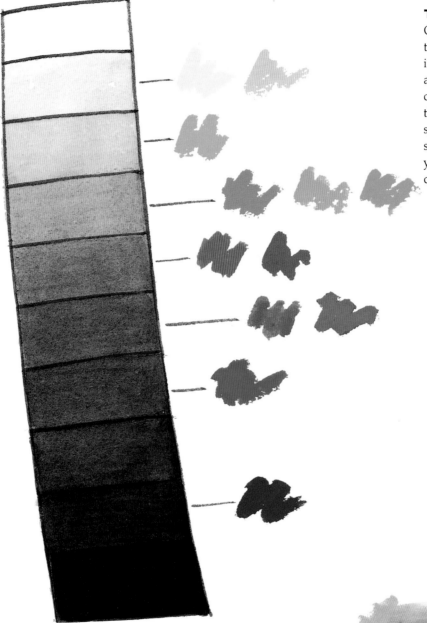

THE SQUINT TEST

One of the best ways to determine the tonal values of an object is to squint at it. Squinting helps to eliminate details and subtle colors, allowing you to concentrate on the large value shapes. In the illustration at left, I've painted splotches of color alongside a value scale. Squint at these colors and see if you can match them up in value with corresponding locations on the scale.

This illustration is a good example of how values change on an object because of the amount of light it is receiving or not receiving. The egg, although smoother and minus the nooks and crannies of the human head, still has the same overall shape. When the egg is lit from above, we can see that the brightest (highest value) of the egg is at the top. As the contour or side of the egg turns down and away from the light it gets darker in value. Notice how the man's head to the right of the egg works the same way. To make this example even more noticeable, turn the book around and view the illustration upside down.

MAKING A VALUE SCALE

Although you can use any medium to make a value scale, pencil might be the easiest. Start by drawing a rectangular box 10" high and 1½" wide on a piece of heavyweight paper. Next, divide the 10-inch dimension into ten 1-inch sections. (For metric measurements, start with a box 25.4cm high and 3.8cm wide and divide it into ten sections.) Now fill in the top box with a soft pencil, such as a 6B or 4B, so that it is a dense black. Next, move your pencil rapidly back and forth, working your way down the scale. Don't be concerned about going outside the lines. As you move down, apply less pressure so that the gradation of pencil marks gets lighter. Try to get an even progression from black at one end of the scale to white at the other. When you have completed this, redraw the horizontal lines that separate the scale into ten parts. Spray the scale with workable fixative to prevent smudging, and cut it out. (This will make it easier to use.)

When starting to paint the model, hold your value scale at arm's length so both model and scale are visible. Squint and try to determine the value and approximate color of a large shape or form on the model. Next, lay your value scale on your palette and mix a color that matches in value with the shape you were viewing on the model.

This illustration shows how the black-and-white value scale helps to determine the values of colors on the model's head.

Mixing Colors

Color mixing can be lots of fun. It can also be frustrating until you get the hang of it. Rather than just listing a bunch of possible skin tone mixtures, I've selected four heads with different skin and hair coloring. Alongside each head are the instructions and mixtures I used to achieve different colors and values. As you look at the color swatches for each mixture, notice that I've made small swatches of each color used in a mixture above a larger swatch of the final mixed color. My mixing instructions are somewhat like Grandma's recipes—"a pinch of this," and "a dash of that." However, with a little practice you should be able to duplicate these mixtures. A few notes to keep in mind while mixing colors:

1. Mix your colors on your palette with a brush rather than a palette knife. Mixing is quicker and more thorough with a brush. Mixing on the palette will keep your colors cleaner, as mixing colors on the canvas can easily produce mud.

2. Keep in mind that the Cadmiums, along with Venetian and Indian Red, are very strong tinting colors and should be used sparingly when starting a mixture.

3. When mixing light colors, I usually start by putting some white on the palette, and then adding colors to it.

The warm lighter areas of hair consist of the same mixture as below with Cadmium Red Light and more Yellow Ochre and white added.

For the light skin color of the forehead, I use a touch of Cadmium Yellow Light, a touch of Alizarin Crimson, and lots of white. For the warm blush color of the cheeks, I use the same colors from the forehead mixture, but increase the strength of Cadmium Yellow Light and Alizarin Crimson in the mixture.

The dark areas of hair are Burnt Umber, Yellow Ochre and a touch of white.

This warm gold dark consists of a little Alizarin Crimson, Raw Sienna and white. The dark value under the jaw consists of Cadmium Yellow Light, Alizarin Crimson and white.

The warm tone of the ear is Cadmium Red Light, Yellow Ochre and white.

The light area of the forehead is a mix of Cadmium Red Light, Yellow Ochre, Cadmium Yellow Light and lots of white.

The dark hat consists of Ultramarine Blue, Ivory Black and Alizarin Crimson.

For this ruddy cheek area, I mixed Cadmium Red Light, Yellow Ochre, a little Cerulean Blue and lots of white.

These rich warm darks are made up of Venetian Red, Permanent Green Light, a touch of Cadmium Red Light and a touch of white.

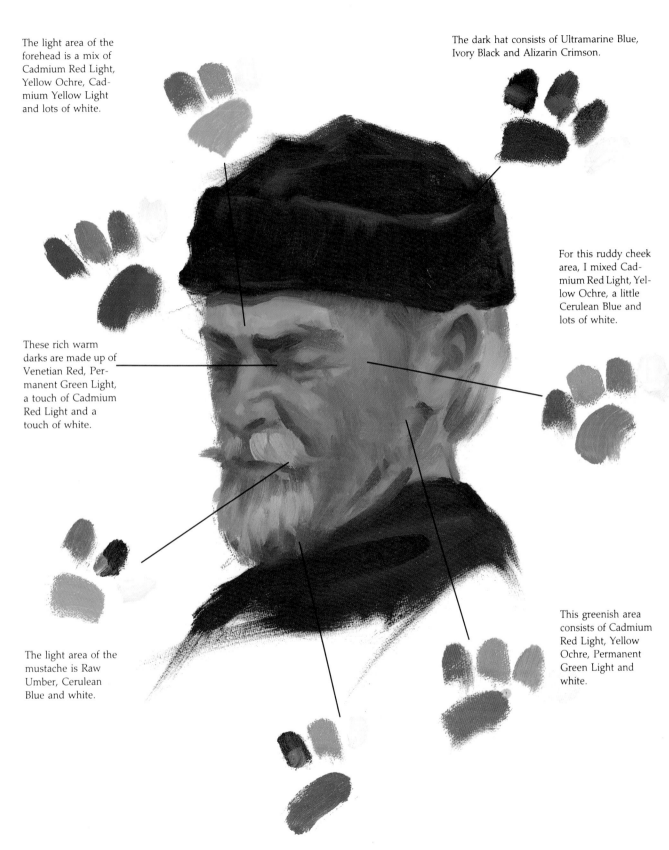

The light area of the mustache is Raw Umber, Cerulean Blue and white.

This greenish area consists of Cadmium Red Light, Yellow Ochre, Permanent Green Light and white.

The warm dark of the beard is Raw Umber, Yellow Ochre and white.

Mixing Colors

The dark hair is Ivory Black, Cadmium Orange and a little white. The light area of hair is the same mixture as for the dark hair with more white and a little more Cadmium Orange added.

The light forehead area is a mix of Burnt Umber, Alizarin Crimson and white.

The dark areas on the side of the forehead are a mixture of Burnt Umber, Alizarin Crimson and a little white.

The side lighting is a mix of Burnt Umber, Cerulean Blue and white.

The light areas on the cheeks and nose consist of Burnt Umber, Alizarin Crimson, Cadmium Orange and white.

The highlight on the nose is Burnt Umber, Cadmium Orange and lots of white.

For the light forehead area, a mix of Cadmium Orange, Cadmium Yellow Light, Raw Sienna and lots of white was used.

This is a light warm shadow area and the mixture consists of Cadmium Orange, Raw Umber, Yellow Ochre and white.

The light area of the hair is Cadmium Orange, Yellow Ochre and white.

The middle tone in the hair is made of Cadmium Orange, Burnt Umber, Yellow Ochre and white.

The rosy cheeks are a combination of Cadmium Red Light, Cadmium Orange, Raw Sienna and white.

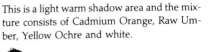

The darkest area of the hair is Burnt Umber and Cadmium Orange.

The warm lip tones come from Cadmium Red Light, Cadmium Orange, Raw Umber and white.

For this darker shadow area, I used Cadmium Red Light, Raw Sienna and white. By adding more white and Raw Sienna to this mixture I arrive at the correct color for the freckles.

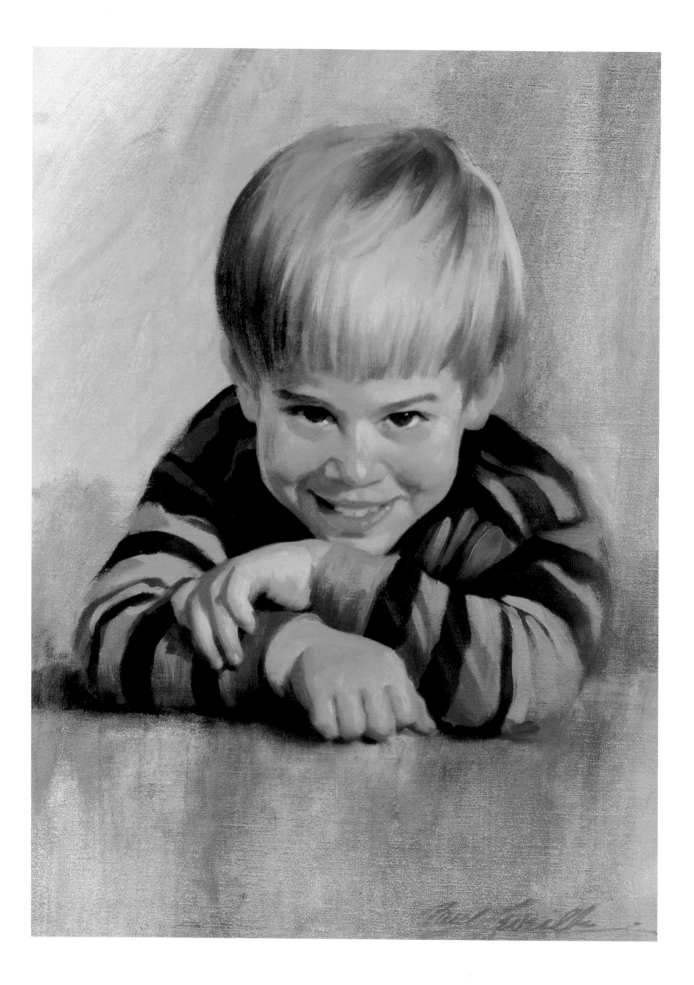

4 Painting the Portrait

STEP BY STEP

If you were going to sculpt a head from a block of clay, would you start by carving an eye? Or would a broader approach, such as carving the overall shape of the head first, be more effective? Next, you would probably try to locate positions and general shapes of the features, like the nose, eye sockets and the overall shape of the mouth and chin areas. You might then slowly refine these big shapes until you were ready to add the details.

The above procedure for carving is exactly how I approach painting a portrait. In the following demonstrations, you will see a variety of models that differ in age, sex, nationality and color. However, you will notice that the same approach of painting the large shapes first is consistent throughout all the demonstrations.

In some paintings you'll see that I am continually moving from one area of the painting to another, while in other paintings I will develop one feature at a time. Once again, the underlying approach is to build the largest shapes first, then move to the next largest shape and so on, until I get to the final details. If the large shapes are correct, then the steps that follow will fall into place.

These demonstrations will reveal a variety of skin colors. Skin colors change not only between men, women, children and race, but also as a result of different lighting. In each demonstration you'll find suggested color recipes for the many skin colors. Try them out and see how they work for you.

NICHOLAS
I wanted the bright yellows and blues of this portrait to convey spontaneity and joy. Notice how the inclusion of his arms and hands in the portrait add to the model's character.

DEMONSTRATION 1
Older Man Wearing Glasses

MATERIALS

- 16″×20″ (40.6cm×50.8cm) cotton canvas
- 2B charcoal pencil and workable fixative
- Filbert bristle brushes in various sizes
- Rembrandt oils
- Permalba White
- Medium (4 parts damar varnish/ 1 part stand oil/4 parts turp)

1 **THE SKETCH**
For this demonstration, start by loosely sketching the head on canvas with a 2B charcoal pencil. Once you complete the sketch, spray it with Blair workable fixative. This will prevent the drawing from smudging when you start painting over it.

2 THE BASIC SKIN TONE

Since I'm working on a white canvas and there are no white values on the model's face, I will cover my sketch with a middle value skin tone. For this skin tone, mix Burnt Sienna, Alizarin Crimson, Raw Sienna and white on your palette. Using a no. 10 filbert, lightly scumble this cool mixture over the sketch. I also brush some of the paint into the background to avoid a "keep in the lines" coloring book appearance.

Use the narrow side of your brush to scumble. Rather than grinding the paint into the canvas, rapidly move the brush back and forth, letting the tooth of the canvas take the paint off the brush.

3 ADDING COLOR TO THE SKIN TONE

The lower part of the face turns in away from the light and is therefore a little darker in value than the upper portion of the head. This model's facial hair will affect the color of the lower section as well.

Using a no. 8 filbert, mix Burnt Sienna, Yellow Ochre and white and scumble this mixture onto the lower section of the face. To achieve the lighter areas on the forehead and under the nose, I remove some paint by wiping with a paper towel.

The color on the cheeks and nose is a ruddy mixture of Burnt Sienna, Yellow Ochre, a little Cadmium Red Light and a touch of white, which is scumbled on.

THE FOREHEAD LIGHT AREA

4 *For this area, mix a light value made up of Yellow Ochre, Burnt Sienna, Cadmium Yellow Light and lots of white. I apply this color to the forehead, and add touches in the background and on the tie—I like to keep colors working together throughout the portrait.*

At this point I want to define the larger dark shapes. By squinting at the model, I can simplify what I see into two groups—dark and light shapes. For the darks, mix Venetian Red, Ultramarine Blue, Cadmium Orange and a little white. By squinting at the color as I mix, I try to approximate the correct value. I also add a little more medium to this mixture to make it more fluid. Using a no. 8 filbert, I apply this color in deliberate strokes that will duplicate the shapes I see on the model while squinting.

THE JACKET AND TIE

5 *In addition to the shadows, this model has a dark jacket and tie. With a no. 11 filbert, mix Ultramarine Blue, Raw Umber, Ivory Black and a touch of white. Lighten the mixture with white for the shoulder nearest the light source. Darken the mixture by adding black and Ultramarine Blue for the shoulder in shadow, the tie and the shadow lines of the lapel on the light side.*

Once the jacket area is completed, I decide to clean up my palette, scraping all previous mixtures off. I also clean all the brushes that I have used. Cleaning up gives me a break from painting. When I start painting again, I feel refreshed and I'm ready to see and mix new colors, rather than reuse old mixtures that usually result in mud or diluted colors.

TIP

During this stage of the painting, I usually add a little medium when mixing paint to make it flow more easily. I like a creamy consistency, but I'm careful not to add too much medium because this can make the mixture watery and too slippery to work with.

6 THE HAIR

For the hair, mix Raw Umber, Alizarin Crimson, Raw Sienna and white. I also apply this color to part of the tie to help pull colors together.

7 THE HALFTONES

Now it's time to start making the transition between the darkest darks and the lightest lights. Using a mixture of Cadmium Red Light, Yellow Ochre, Permanent Green Light and white, start to paint the greenish halftone shapes around the chin and mouth. As you move up toward the cheeks, add more Cadmium Red Light, Yellow Ochre and white to the mixture. For the nose, use Cadmium Red Light, Raw Sienna and white. The ear is lighter in color and value, so use Cadmium Red Light, a little Yellow Ochre and white.

On the dark side, paint the forehead with Burnt Sienna, Yellow Ochre, a touch of Cadmium Red Light and a touch of white. As the forehead turns into the light, mix more white with Yellow Ochre and Cadmium Red Light.

As you come down the shadow side from the forehead, paint the temple area with Burnt Sienna, Yellow Ochre and white. For the cheek, add a little more Cadmium Red Light to the above mixture.

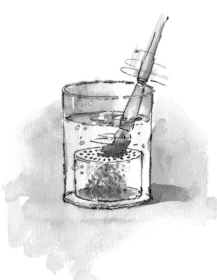

While wearing rubber gloves to protect my hands, I rinse my dirty brushes in an empty coffee can containing Turpenoid. Inside this can is a smaller can that is turned upside down. Holes have been punched in the bottom of this can to allow paint sediment to drop through to the bottom. After rinsing each brush, I wipe it dry with a section of paper towel.

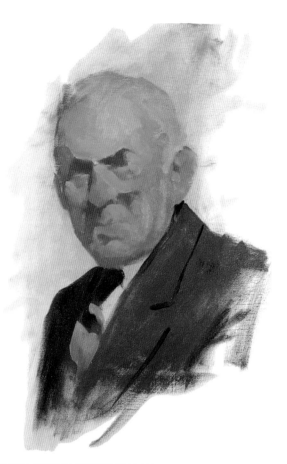

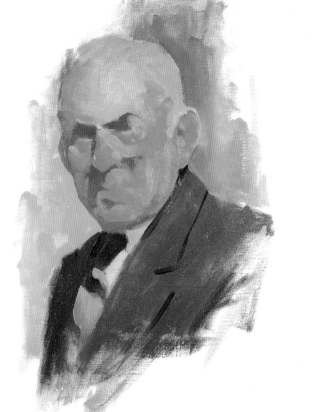

8 **THE LIGHTER HALFTONES**
Continue to build the lighter value shapes. A mixture of Cadmium Red Light, Raw Sienna and white is used on the lips as well as under the eyes and on the tip of the forehead as it rolls away from the dark.

For the lighter areas under the nose, the top of the chin and the folds on the light side of the cheeks, use Burnt Sienna, Yellow Ochre and white. Add a little more white and a touch of Cadmium Red Light to this mixture to paint the area around the lips.

Lastly, mix Burnt Sienna, Cadmium Yellow Light and white and paint the areas above the upper lip and light areas on the cheekbones and forehead. Notice how I run this color from the forehead up into the hair. This will give a more natural look to the hairline.

9 **THE BACKGROUND**
It's time to introduce a background I choose a cool color to complement the warm nes. With a no. 11 filbert, mix Cerulean Blue, Yellow Ochre and white for a light background color. I want to add a darker background in back of the light side of the head for contrast. For this area, mix Cerulean Blue, Ultramarine Blue, Raw Umber and white. I also add a mix of Yellow Ochre and white to parts of the background to bring in some of the warm face tones.

TIP

After I make a stroke with my brush on the painting, I bring my brush back to the palette and dip it into the paint mixture I am using. Then I go back to the canvas and make another stroke, then back to the palette. This helps to keep my painting clean and crisp. Too many strokes on the canvas without adding fresh paint to the brush can result in mud.

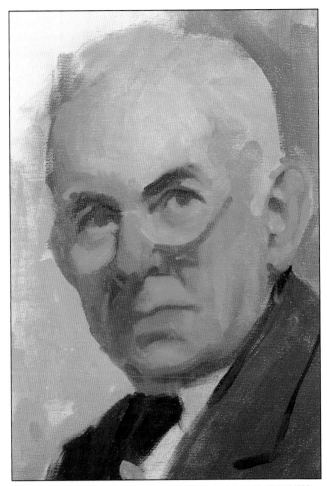

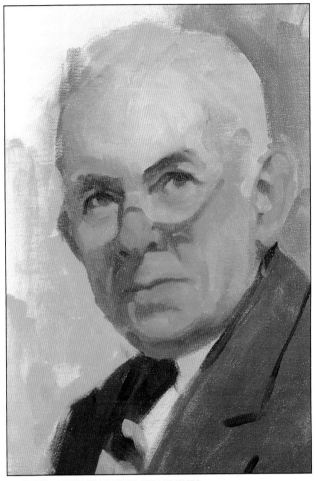

10 **REESTABLISHING DARKS AND HALFTONES**
Using Venetian Red, Cadmium Orange and white, add warm darks under the eyebrows and nose. A darker mix of Venetian Red, Permanent Green Light and white is used under the chin and in small areas under the nose.

For the eyebrows, use Burnt Umber. For the darks around the eyes and nostrils, use Burnt Umber, Venetian Red and a little white.

Cadmium Red Light, Yellow Ochre and white make up the light color of the ear.

The ruddy complexion on the nose needs more color. Add Burnt Sienna, Cadmium Red Light and white. I also add this color around the lips.

The irises are painted in with Burnt Umber, Cadmium Orange and white.

11 **REFINING THE FEATURES**
Eyes. Warm colors on the upper lids are painted with Burnt Sienna, Cadmium Red Light, Yellow Ochre and white. Paint the dark shadows on the iris with Burnt Umber. The dark line of the upper lid is painted with Burnt Umber and Cadmium Red Light.

Nose. Add a lighter value to one side of the bridge of the nose with Cadmium Red Light, Burnt Sienna and white. Define the dark nostrils with Burnt Umber, Cadmium Red Light and a touch of white. The shadow side nostril is Burnt Umber and a little Cadmium Red Light. The nostril on the light side receives a little light through the wing of the nose. Use a warm dark mixture of Burnt Umber with Cadmium Red Light and a little white.

Mouth. Redefine the lips, keeping the shapes simple. The upper lip is in shadow, so use a dark mixture of Cadmium Red Light, Raw Umber and white. For the lower lip, which is in the light, mix Cadmium Red Light, Raw Sienna and white. Using a no. 4 filbert, paint the dark line between the upper and lower lips with Burnt Umber and Cadmium Red Light. This mixture is also used for the shadow on the bridge of the nose caused by the glasses, and for the partially hidden right ear.

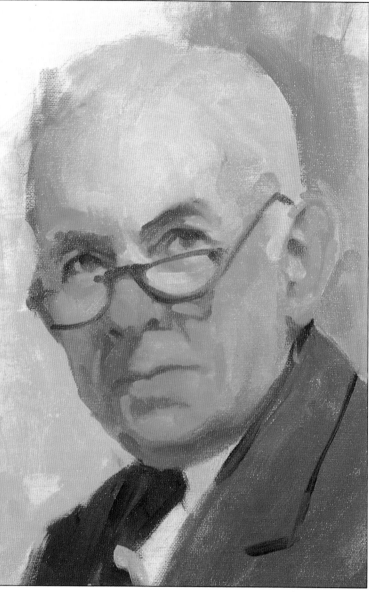

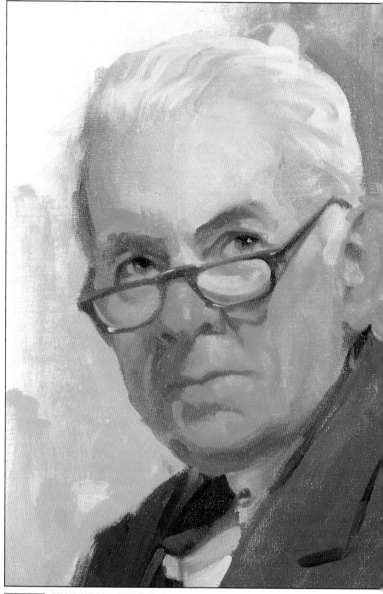

12 **THE GLASSES**
Rather than painting the glasses solid black—which would make them too dominant—I use a softer mixture of Ultramarine Blue, Ivory Black and white. Using this softer color for the glasses will help them merge with the face. Paint small sections of the glasses on both sides, trying to keep the oval shapes similar.

13 **THE FINAL DETAILS**
Glasses. *Add the light areas on the inside of the rims with Raw Sienna, Burnt Sienna and white. The top ridges of the frame are receiving more light than the front. For this area, add more Venetian Red and white to the original frame mixture for a light purple color. Last, add highlights to the frames using white with a touch of Yellow Ochre.*

Eyes. *Add the pupils to the eyes with a mixture of Ivory Black and Burnt Umber.*

Highlights. *Add the highlights to the eyes with white, Yellow Ochre and Cadmium Yellow Light. For the nose and lips, add a touch of Cadmium Red Light to the above mixture.*

Hair. *Add darks to the hair using Venetian Red, Ivory Black, Raw Sienna and white. The light areas are Raw Umber, Yellow Ochre and lots of white.*

14 **THE COMPLETED PORTRAIT**

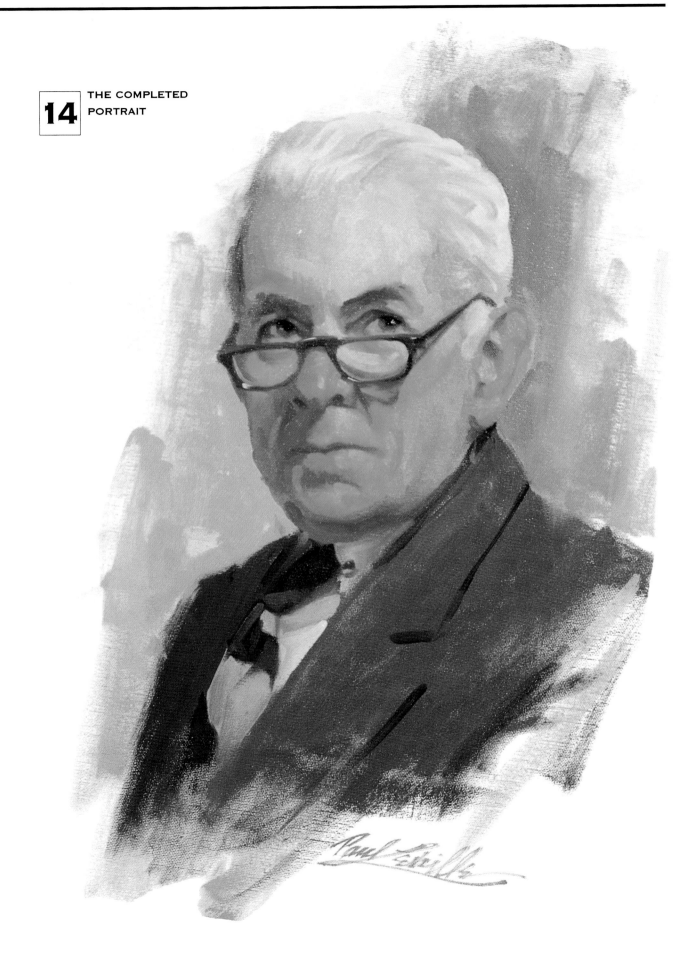

MR. JOSEPH KOURY, *45″ × 40″ (114.3cm × 101.6cm)*

MR. SAM SALEM,
36" × 41" (91.4cm × 104.1cm)

These two finished portraits employ some of the same techniques used in the previous demonstration.

DEMONSTRATION 2
Man With a Beard

1 **THE SKETCH**

For this portrait I decided to forego using charcoal and started directly with paint. The color I use to sketch with is determined by the predominant color in the shadow areas—in this case I see a dull purple. To create this purple, mix Ultramarine Blue, Alizarin Crimson, white and a little Yellow Ochre. Now sketch directly on the white canvas with a no. 6 filbert. Notice at this stage I do not use a medium to thin the paint. I prefer to use a dry brush technique. A medium would make the paint too thin and slippery and cause additional applications of paint to "slide" and not adhere as well on the canvas.

2 **THE BASIC SKIN TONE**
Since there are no white areas on the face, brush a light skin tone of Cadmium Red Light, Yellow Ochre, a touch of Cerulean Blue and white over the face. Let this color go off into the background as well to avoid butting the color up to edges, which can be unattractive and tight looking. Notice that I do not "scrub" the paint into the canvas but "scumble" it on lightly using the narrow side of my brush. This allows the underdrawing to show through.

3 **ADDING COLOR TO THE SKIN TONE**
Using a no. 8 filbert, brush a ruddy mixture of Cadmium Red Light, Alizarin Crimson, Yellow Ochre and white over the cheeks and nose area. The lower portion of the face has a more golden tone. Mix Raw Sienna, Cadmium Red Light and white and apply it to the lower jaw area and under the right eye.

4 **THE DARKS**
Although colors and values change a little within the shadows, I keep things simple by mixing one dark shadow color. Using a mixture of Venetian Red, Ultramarine Blue, a touch of Cadmium Red Light and a little white, paint in the big shadow shapes.

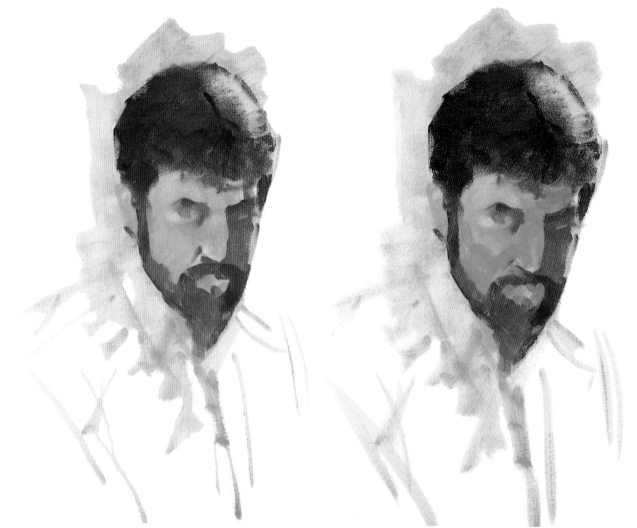

 THE DARKS IN THE HAIR
The next dark areas to tackle will be the hair, including the beard. For these areas use Burnt Umber and Cadmium Orange.

 THE HALFTONES
At this time I decide to add a few halftones to the mouth area, cheeks, nose and forehead. Around the mouth use Burnt Sienna, Yellow Ochre and white.

For the other halftone areas use Cadmium Red Light, Yellow Ochre and white.

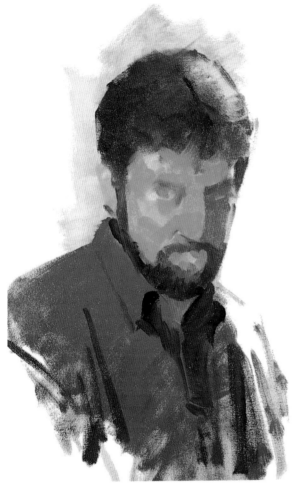

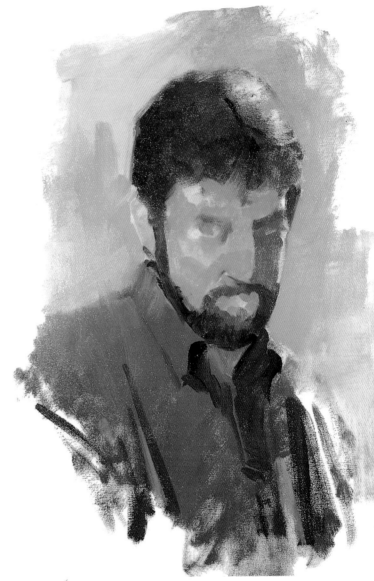

7 **THE SHIRT**
Before you do any more work on the face, you should include the shirt and background. I simplify by using only two values for the shirt. The light value is a mix of Ultramarine Blue, Raw Umber and white. The dark value is Ultramarine Blue, Ivory Black and a touch of white.

8 **THE BACKGROUND**
Loosely paint in some cool tones of Cerulean Blue and white. This color will tie in with the model's blue eyes. A lighter and warmer value color is introduced with a mixture of Yellow Ochre, Cadmium Red Light and white. This color is similar to the skin tone and lets the head and background exist harmoniously.

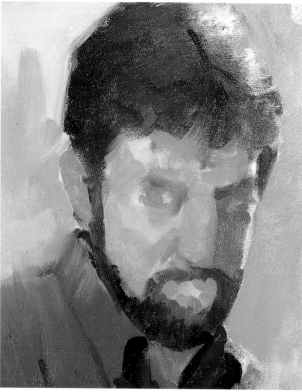

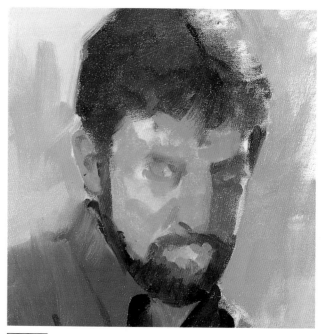

10 **THE DARKS IN THE EAR**
For the darks of the ear a mixture of Cadmium Red Light, Venetian Red and a touch of white is used. This color is also painted under the nose and the left eye.

9 **THE EAR**
Using a mixture of Cadmium Red Light, Burnt Sienna and white, block in the ear. Since this color can be seen in other areas, paint it in along the bridge of the nose between the light and shadow areas and under the model's right eye.

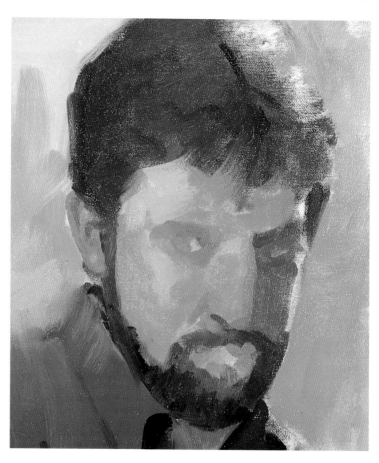

11 **THE FOREHEAD AND CHEEKS**
For the bright area of the forehead, use Alizarin Crimson, Cadmium Yellow Light and white. Build halftone areas around the model's right eye with Raw Sienna, Burnt Sienna and white. The cheeks receive more ruddiness with a mixture of Cadmium Red Light, Yellow Ochre and white.

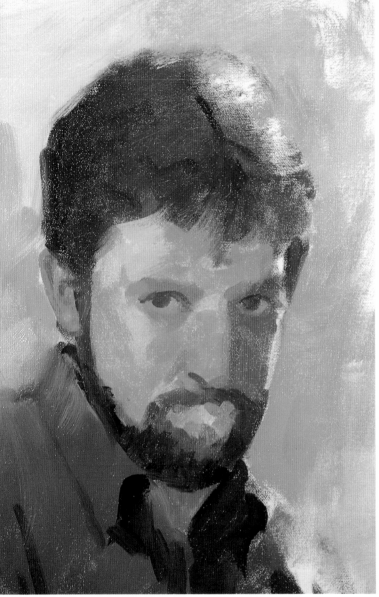

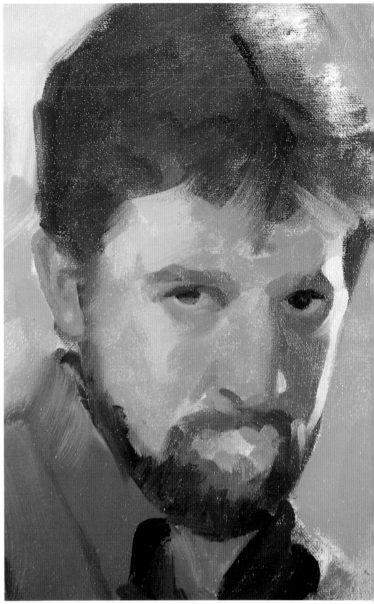

12 **THE EYES**
As you can see, we have been building the features by painting the large values and colors around them. We'll now continue with the smaller shapes around the eyes. The dark upper lid of the right eye is painted in with Raw Umber, Alizarin Crimson and white. The shape of each iris is added with a mixture of Ivory Black, Ultramarine Blue and white. Notice that the eye in shadow is a darker value than the eye on the light side of the head. Simply use less white in the mixture for the darker eye.

13 **THE EYES AND SIDE LIGHT**
There is a dark shadow on the upper portion of the model's right iris. Using a no. 4 filbert, paint the shadow in with Ivory Black, Ultramarine Blue and a touch of white. Add a darker value to the model's right eyebrow with a mixture of Raw Sienna, Raw Umber and white. Moving to the shadow side of the head, define the bright side lighting with a mixture of Yellow Ochre and white.

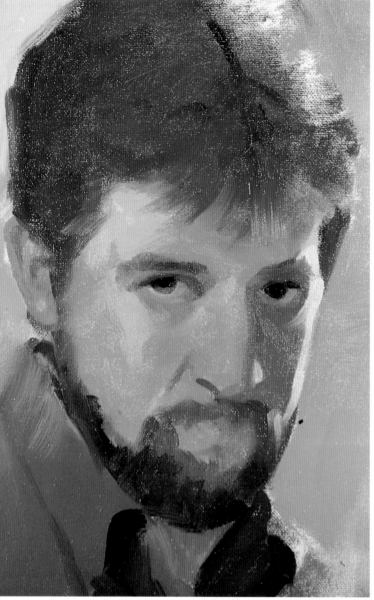

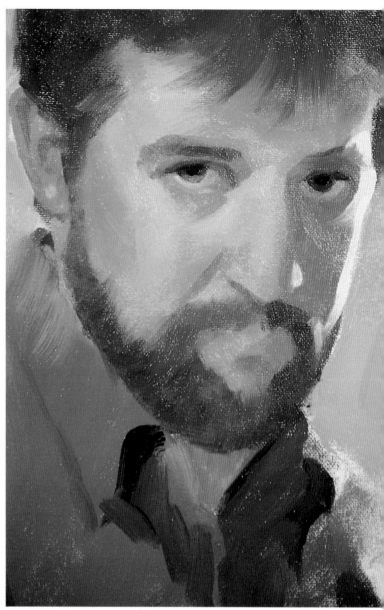

 14 THE EYEBROWS, HAIR AND MOUTH HALFTONES

The dark areas of the eyebrows are painted in with Burnt Umber. The pupils are added using Ivory Black. The hair over the forehead is defined more using Burnt Umber, Yellow Ochre and white.

Moving toward the lower part of the face, paint halftones around the mouth with Burnt Sienna, Raw Sienna and white.

 15 THE HALFTONES ON THE LIGHT SIDE OF THE FACE

The cheekbone has a little more ruddiness to it. Paint this tone in with Alizarin Crimson, Burnt Sienna and white. The lower cheek near the beard is painted with Raw Sienna, Burnt Sienna and white. To give the beard more shape, redefine the darks with Burnt Umber, Cerulean Blue and white. The lighter parts of the beard are painted in with Burnt Umber, Yellow Ochre and white. The shapes around the mouth are also redefined.

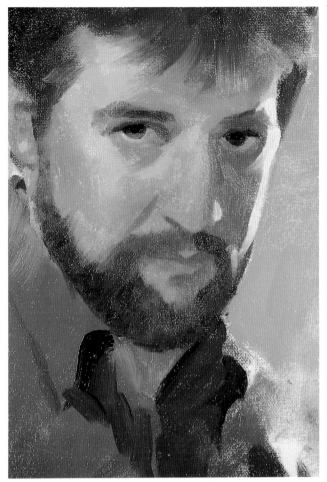

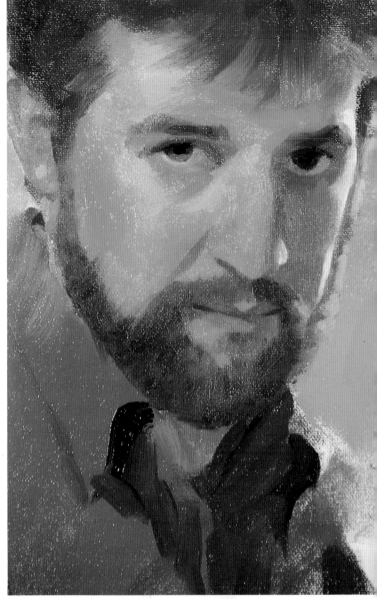

16 **THE LIPS**
Now that the general form of the mouth area has been painted, it's time to paint the lips. Using a no. 4 filbert mix Cadmium Red Light, Alizarin Crimson, Raw Umber and white and paint the shape of the upper lip and the shadow it casts on the left side of the model's lower lip. The lower lip is receiving more light so it is lighter in value and warmer in color. Paint it in with a mixture of Cadmium Red Light, Alizarin Crimson, Yellow Ochre and white.

There may be times when your painting has taken a wrong turn. When the paint has built up on the canvas too much and added paint strokes just get muddy, the best solution may be to scrape the paint off and start again. However, there is an alternative. Lay a piece of newsprint on the overworked area. While holding the newsprint in place, rub the surface of the paper with your hand. Now pull the paper off the canvas. The paint has blotted to the newsprint and your original image remains intact on the canvas. Repeat this process until enough of the undesirable paint has been removed.

17 **DIVIDING THE LIPS**
The dark line between the lips is painted with a well worn no. 4 filbert that has a fine point to it. Use a mixture of Venetian Red, Burnt Umber and a touch of white. Notice that I don't paint this shape a solid dark line from one end of the mouth to the other. The line is kept a little heavier and darker at the ends of the mouth, and it gets thinner and lighter toward the middle.

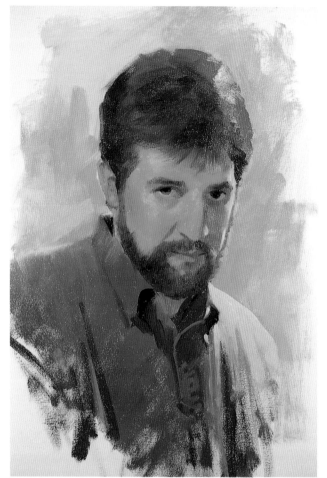

THE HAIR AND SHIRT

18 *Redefine the darks and midtones of the hair using Burnt Umber, Cadmium Red Light, Cadmium Orange and white. The lights on the shirt are defined with Cerulean Blue, Yellow Ochre and white.*

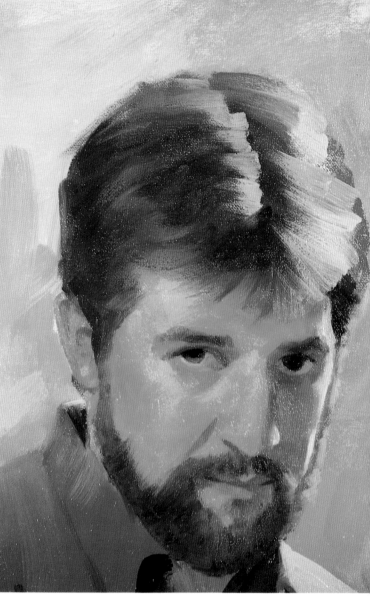

ADDING HIGHLIGHTS TO THE HAIR

19 *Add the highlights to the hair with a no. 12 filbert using a mixture of Burnt Umber, Cerulean Blue and lots of white.*

I finish the hair by blending the highlights into the darker values with a fan brush. Remember, when using a fan brush in this type of situation, make only one stroke on the canvas, then dip the fan brush back into your paint mixture. This will keep your colors and values crisp and clean.

20 **THE COMPLETED PORTRAIT**
Complete the portrait by adding highlights to the lower lip and nose with Cadmium Red Light, Yellow Ochre and lots of white. The highlights in the eyes are dropped in with a mixture of Yellow Ochre and white.

DEMONSTRATION 3

Woman With Red Hair

1 THE SKETCH

For this demonstration I sketched directly on the white cotton canvas with a medium density vine charcoal. Vine charcoal can be shaped into a point by rubbing one end on a piece of sandpaper or a sandpaper block. Remove charcoal lines from the canvas with a simple wipe of a clean rag.

Start the sketch by making a mark for the position of the top of the head, about two inches down from the top of the canvas. Next, make a horizontal mark to indicate the location of the bottom of the chin. Continue to draw and define the head and its features.

When you're satisfied with the drawing, take it outside and spray it with Blair odorless workable fixative. This will prevent the drawing from smearing when you add paint over it.

TIP

It's easy to remove charcoal lines from the canvas with a simple wipe of a clean rag.

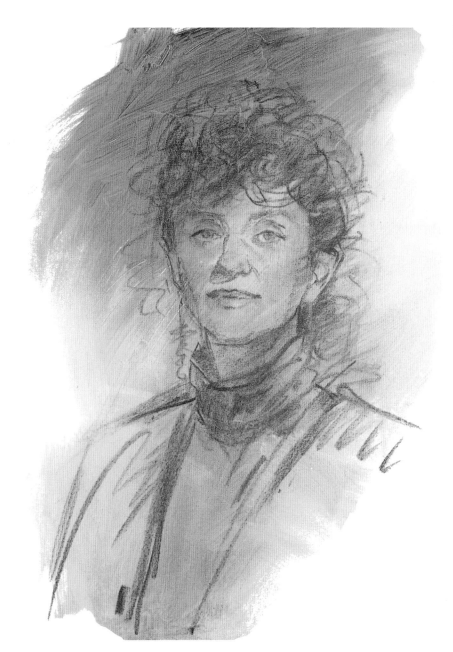

THE WASH

2 *After the fixative dries, apply a wash of Viridian and turp. This color will complement the red hair. Also add a wash of Yellow Ochre to parts of the drawing.*

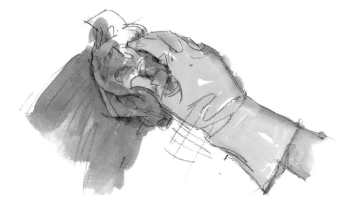

Here's an easy way to put a colored wash on your canvas. While wearing rubber gloves crumple up a sheet of paper towel in your hand and dip it into turp, then mix it on your palette with the color you wish to use for the wash. When you have the paper towel well saturated with the thinned paint mixture, apply the color moving rapidly over the drawing on the canvas. When you have completely covered the canvas it's a good idea to let it stand outside to dry. This will prevent the turpentine fumes from overpowering your work area.

 THE LIGHT SKIN TONES
After letting the wash dry, scumble a mixture of Alizarin Crimson, Cadmium Yellow Light and white over the face. Then add Cadmium Red Light and Yellow Ochre to the above mixture and brush it across the cheeks and nose. Also move some of this color loosely onto the shoulders.

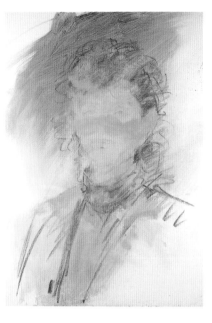

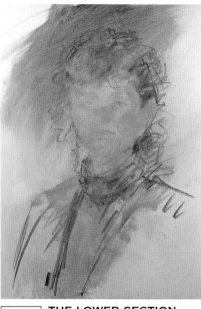

 THE LOWER SECTION OF THE FACE
To the lower section of the face add a mixture of Raw Sienna, Burnt Sienna and white. This area is more golden compared to the ruddy cheeks. With a piece of paper towel wipe some color off the brightest area of the forehead and under the nose.

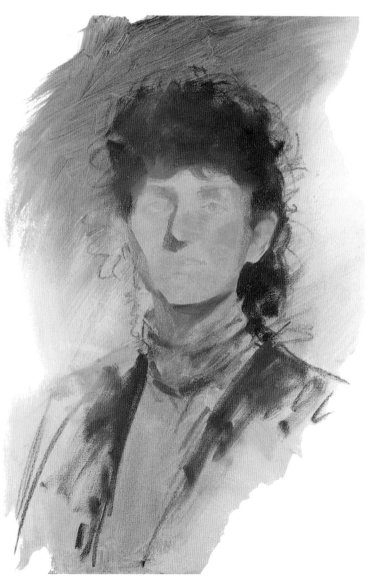

5 **THE DARK SHADOWS**
At this point I squint to see just the big dark shapes. Paint them in with a mixture of Cadmium Red Light, Permanent Green Light, Yellow Ochre and white.

The next big dark shape to tackle is the hair. Paint this dark area in with Burnt Umber, Cadmium Orange and white. Once the hair is blocked in, add a little Alizarin Crimson to the above mixture and scumble it over the jacket area, then add a few dashes to the hair.

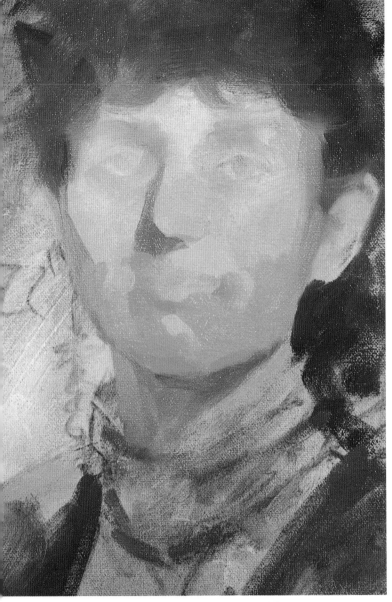

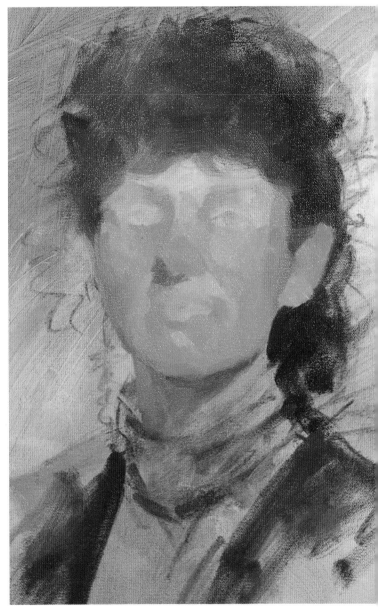

6 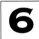 **THE HALFTONES AROUND THE MOUTH AND CHIN**

Using a mixture of Burnt Sienna, Raw Sienna, Cadmium Orange and white, block in the halftone shapes around the mouth and chin. Also add a touch of Cadmium Red Light and white for the pink area on the end of the chin. The light areas above and on the sides of the mouth are painted in Cadmium Red Light, Yellow Ochre and white.

7 **THE CHEEKS AND NOSE**

For the cheeks and nose, mix a more ruddy color of Cadmium Red Light, Yellow Ochre, Burnt Sienna and white. Add a little more Cadmium Red Light and Burnt Sienna to the mixture for the outside of the cheeks to darken the value as the cheeks turn away from the light. Paint the upper portion of the ear with the same mixture. The lobe of the ear is receiving more light, so paint this area with a mix of Yellow Ochre, white and a touch of Cadmium Red Light.

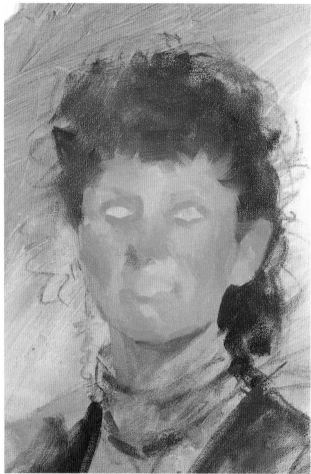

8 THE EYES
To paint the areas to the outside of the upper lids, use a cool mixture of Alizarin Crimson, Cerulean Blue, Burnt Sienna and white. The sides of the upper lids toward the nose are warmer. A mixture of Cadmium Red Light, Burnt Sienna and white is used. Paint the area under the eyes with the same mixture.

The forehead is receiving more light and is less ruddy in color. Paint this area with Yellow Ochre, Cadmium Red Light and white. Add a little more white to this mixture for the lightest areas of the forehead.

TIP

At this time I take a break and clean my brushes with Turpenoid and scrape and clean my palette as well. This cleaning process tends to clear my mind, allowing me to return to my painting and view it with a fresh eye.

9 BUILDING UP THE SHIRT, NECK AND MOUTH
Paint in the light areas of the model's jersey top using a mixture of Cerulean Blue, Viridian, a touch of Permanent Green Light and white. For the darker shadow areas, use Ultramarine Blue, Burnt Sienna and white.

Paint in the reflective lights under the chin with a mixture of Cerulean Blue, Permanent Green Light, Burnt Sienna and white. Now darken the shadow under the chin using Burnt Sienna, Permanent Green Light and a touch of white.

The light area on the neck is redefined with Cadmium Red Light, Burnt Sienna and lots of white. Add a warm mixture of Cadmium Red Light, Burnt Sienna and a touch of white for the ear on the shadow side of the head.

To develop the mouth area and capture subtle halftones, use mixes of Burnt Sienna, Raw Sienna, Cadmium Orange and white. Notice how the chin now appears to come forward and the right side of the model's mouth recedes.

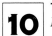 **THE LIPS**

Paint both upper and lower lips as one shape. A mixture of Cadmium Red Light, Burnt Sienna, Cadmium Orange and white is used. A mixture of Cadmium Red Light, Raw Umber, Cadmium Orange and white is used for the ends of the upper lip and the corners of the mouth. The light halftone area of the lower lip is painted in using Cadmium Red Light, Cadmium Orange and white.

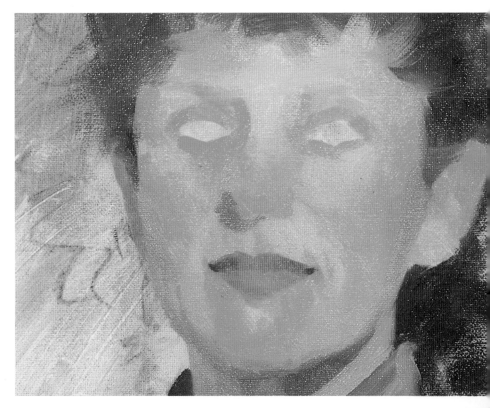

11 **FINISHING THE LIPS**

For the thin dark line between the lips, use Cadmium Red Light, Raw Umber and a touch of white. Notice that the line varies in weight, getting lighter toward the center of the lips. This produces a more natural look. Add a highlight with a no. 4 filbert using a mixture of Cadmium Red Light, Burnt Sienna and lots of white. Keep in mind that although highlights may appear to be solid white in contrast to the surrounding darker values, they are usually a mixture of colors, such as the one just used.

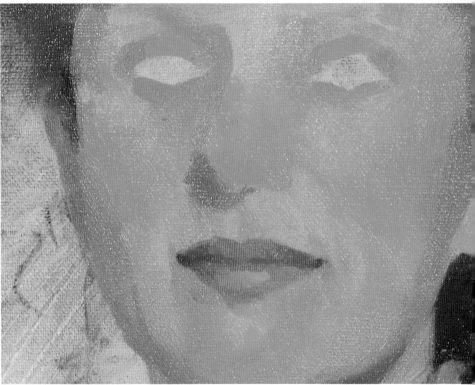

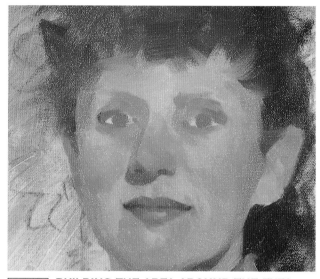

13 BUILDING THE AREA AROUND THE EYES
To build the form around the eyes, start by painting the darkest shapes over the eyes using Burnt Umber, Alizarin Crimson and white. For the lighter bluish halftones, add a bit of Cerulean Blue to the above mixture. Under the eyes add warmer notes of Raw Sienna, Burnt Sienna and white. Also use a bit of this color near the eyebrow area. The warm ruddy tone on the upper lids is a mixture of Cadmium Red Light, Burnt Sienna and white. Repaint some light areas around the eyes with Yellow Ochre, Burnt Sienna and white.

12 THE NOSE
Moving up to the nose, repaint the shadow shape more accurately with a mixture of Cadmium Red Light, Burnt Sienna, Yellow Ochre and white. Lighten the value and color of this mixture by adding a little Cadmium Orange and paint in the wing on the shadow side of the nose. The warm dark under the wing and nostril on the light side of the nose is painted in using a mixture of Cadmium Red Light, Burnt Sienna and white. For the nostril on the shadow side, use Burnt Sienna, Raw Umber and white. On the light side, add Cadmium Red Light for a warmer dark.

Loosely paint in the eyes for position with Cerulean Blue, Raw Umber, a touch of Permanent Green Light and white.

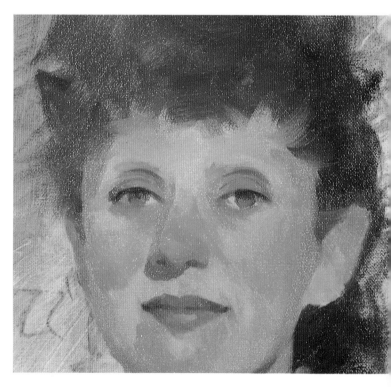

14 THE EYES
The upper lids cast shadows over the upper section of each iris. Paint this shadow in using Ultramarine Blue, Raw Umber and white. For the dark part of the upper lashes use Venetian Red, Ivory Black and a touch of white. For the warm darks of the lashes, use Burnt Sienna, Cadmium Red Light and white. The warm dark lines over the upper lids are painted in with Burnt Sienna, Raw Umber and white.

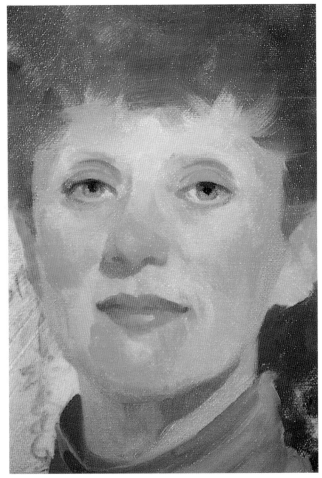

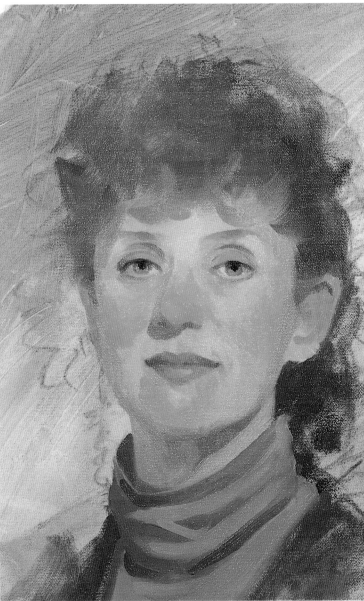

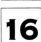

15 **DETAILING THE EYES**
The lower lashes are treated more softly than the upper lashes. Paint them in with a lighter value made up of Raw Umber, Yellow Ochre and white. The "shelf" of the lower lash is a light skin mixture of Cadmium Red Light, Yellow Ochre, Burnt Sienna and white. The pupils are painted in with Ivory Black.

16 **THE EYEBROWS AND DARKS**
The eyebrows are painted in using Raw Sienna, Raw Umber and white. The darks of the ear are added using Vermilion, Burnt Sienna and white. This same dark is painted on the forehead as shadow areas caused by the model's bangs.

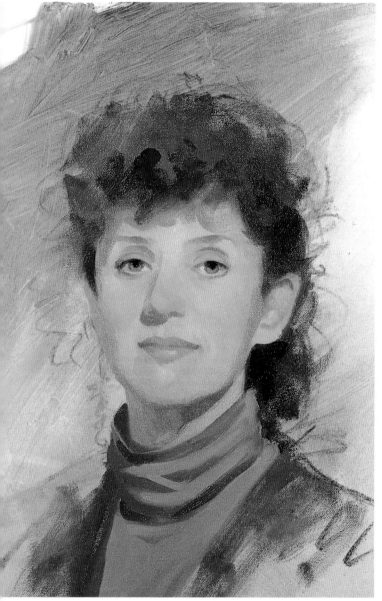

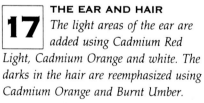 **THE EAR AND HAIR**
The light areas of the ear are added using Cadmium Red Light, Cadmium Orange and white. The darks in the hair are reemphasized using Cadmium Orange and Burnt Umber.

18 **THE HAIR**
The middle values in the hair go in next, using Burnt Umber, Cadmium Orange, Yellow Ochre and white. Try to keep your strokes loose and moving in the natural direction of the model's curls.

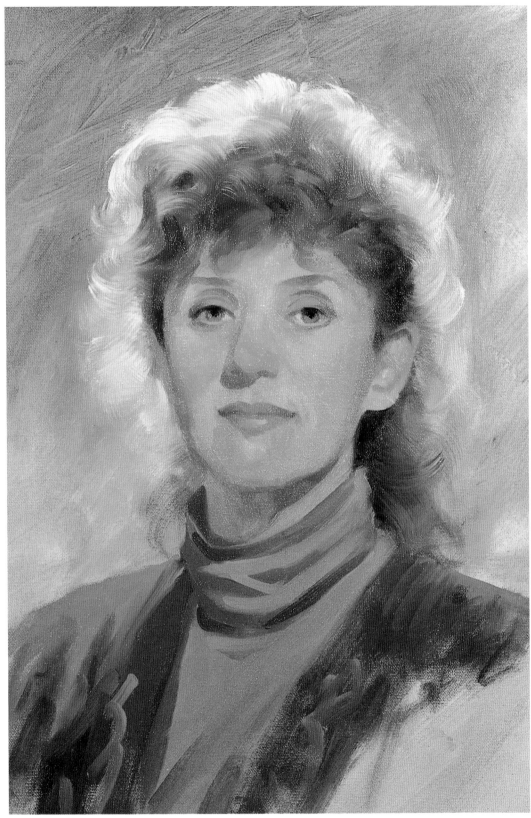

THE HIGHLIGHTS IN THE HAIR

19 *Using a no. 12 filbert, paint in the highlights in the hair caused by strong backlighting using Cadmium Yellow Light, white and a touch of Cadmium Orange. To soften the look of the backlit hair, blend it with a fan brush.*

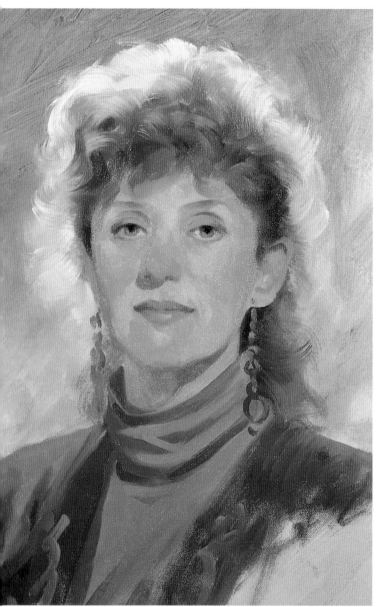

 THE EARRINGS
20 *The best way I've found to paint jewelry is to keep it simple. Start by painting in the dark shapes using Burnt Umber, Permanent Green Light and white. Next paint the middle tones with Burnt Umber, Cadmium Orange and white.*

 THE HIGHLIGHTS
21 *Finally add the highlights to the earrings using a mixture of Yellow Ochre and lots of white. The highlights on the nose and eyes are a mixture of Cadmium Red Light, Yellow Ochre and lots of white.*

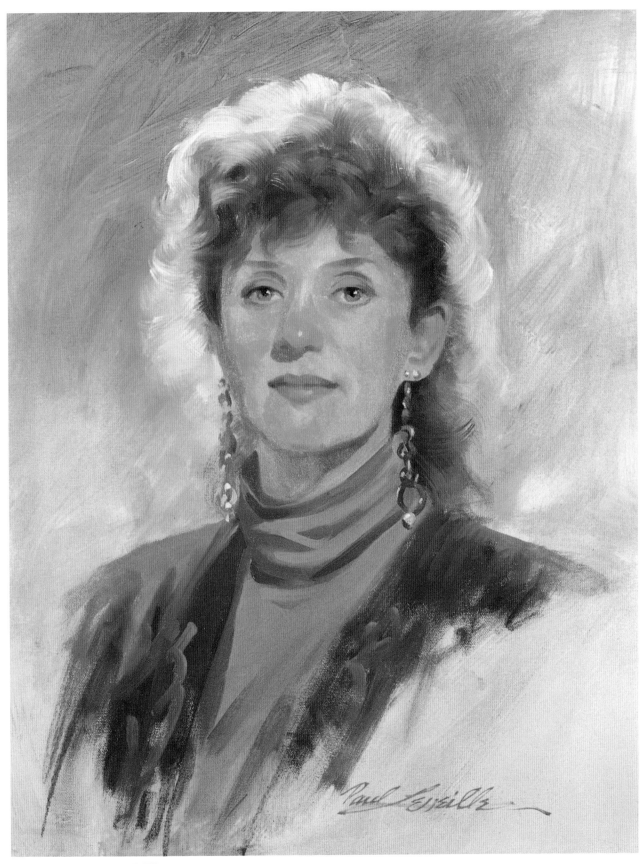

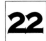 **THE COMPLETED PORTRAIT**

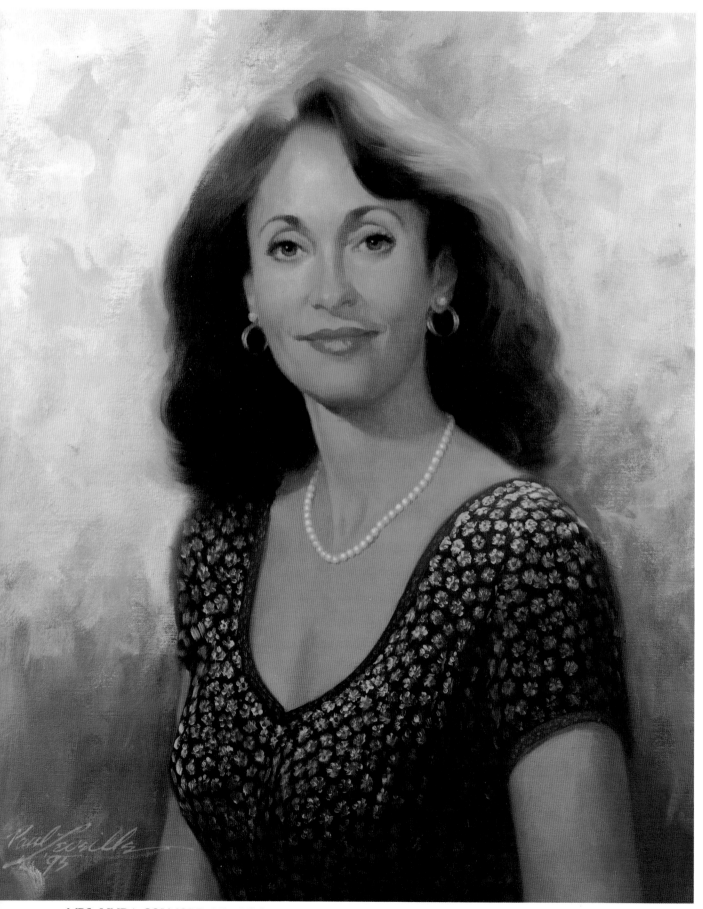

MRS. LINDA COLMORE, 24″ × 20″ (61cm × 50.8cm)

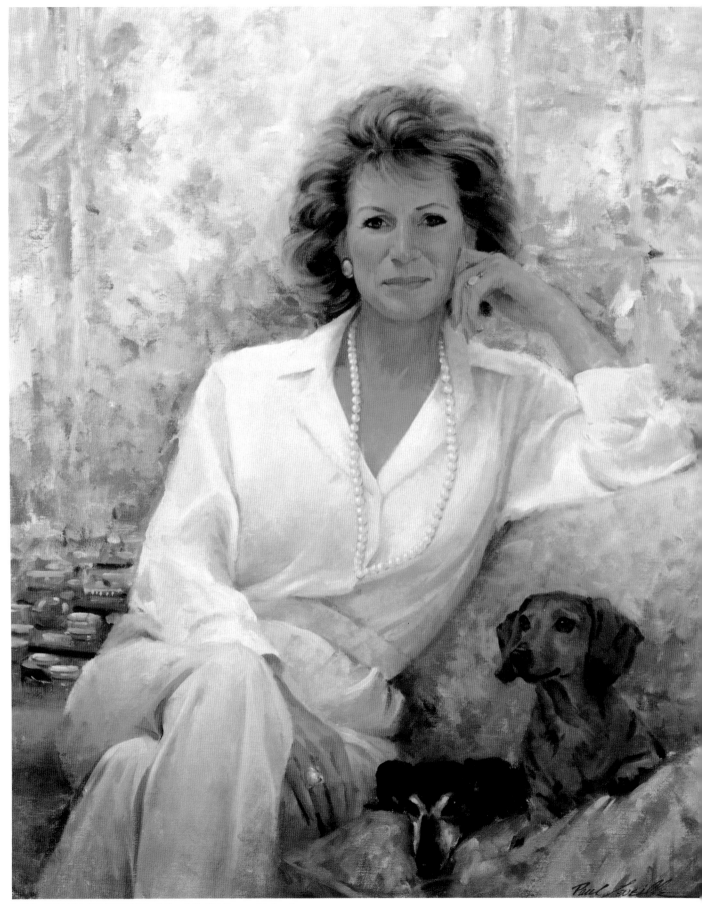

MRS. DIANA PINKHAM, *38" × 32" (96.5cm × 81.3cm)*

DEMONSTRATION 4
Woman Wearing a Hat

1 **THE SKETCH**

I decide to sketch this portrait directly onto a white cotton canvas with paint. Using a no. 6 filbert and a lavender color paint, make a mark a couple of inches from the top of the canvas. This mark represents the top of the head. Make a similar mark near the middle of the canvas to represent the bottom of the chin.

Continuing to sketch with a dry-brush technique—that is with little or no medium mixed with the paint—paint a vertical center line to indicate the tilt of the head. Next paint a horizontal line to indicate the placement of the eyes. Then make marks that represent the location of the bottom of the nose and the lips. Sketch in the hat and neck. Add the shoulder and collar of the blouse. Soften the shadow areas by wiping some paint off using a paper towel with some turp on it.

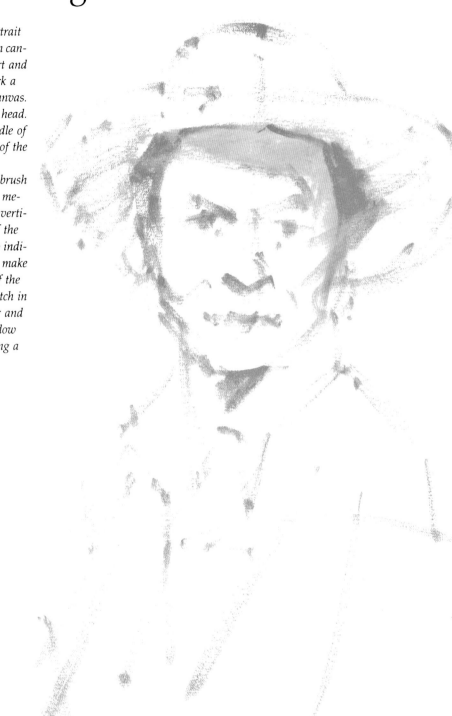

2 **THE BASIC SKIN TONE**
Using a no. 8 filbert, scumble a light skin tone of Burnt Umber, Cadmium Orange, Cadmium Yellow Light and white over the face. As is often the case, the cheeks and nose have more warmth to them. With that in mind, scumble a mixture of Cadmium Red Light, Cadmium Orange and white over the cheeks and nose.

The lower portion of the face is receiving less light, so paint this area with a mixture of Burnt Umber, Cadmium Orange, Cadmium Yellow Light and white. Simply add a little more Burnt Umber and Cadmium Orange to the first skin-tone mixture to get a darker value. Use a paper towel to wipe paint from the area above the lips to achieve a lighter value.

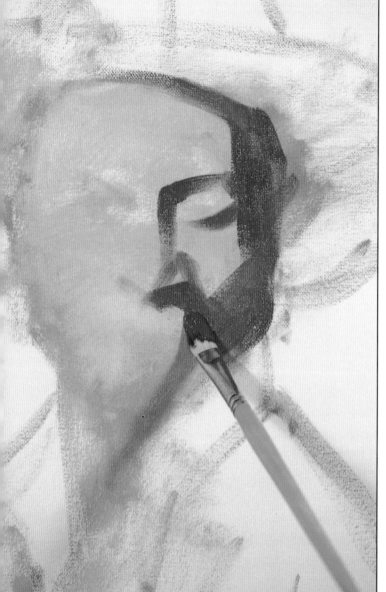

 THE DARKS
Using a no. 6 filbert, paint the dark shadows with a mixture of Cadmium Orange, Alizarin Crimson, a touch of Burnt Umber and white.

4 **THE FACE AND HAIR**
As the form of the face turns toward the light, lighten the shadow color by mixing Cadmium Orange, Yellow Ochre, Alizarin Crimson and white. The dark hair is a mix of Ivory Black and Burnt Umber.

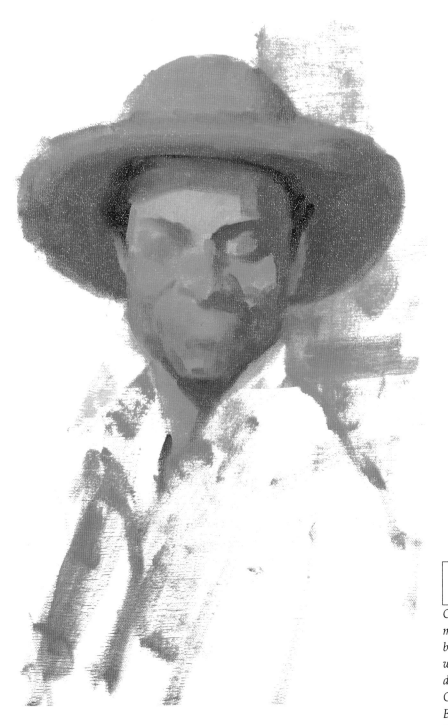

THE HAT

5 Starting with the light value of the hat, use a mixture of Alizarin Crimson and white with a touch of Cadmium Red Light. Move this color into the background and down the shirt so that it won't be isolated in the hat. Develop the darker colors of the hat using Alizarin Crimson, Cadmium Orange, Cerulean Blue and white. The deeper values near the head are a mixture of Alizarin Crimson, Ultramarine Blue and white.

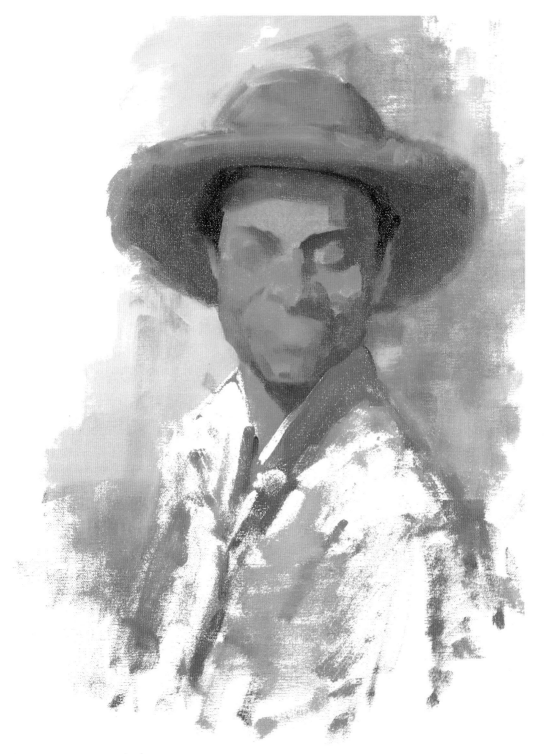

THE BLOUSE AND BACKGROUND

The shadow areas on the collar and shoulder are a mix of Ultramarine Blue, Alizarin Crimson, Cadmium Red Light and white. The background receives a warm yellow color made up of Cadmium Yellow Light, Yellow Ochre and white. I bring this color into the blouse as well. Add a light blue on the blouse using Cerulean Blue, Viridian and white. Also throw a few of these cool touches into the hat.

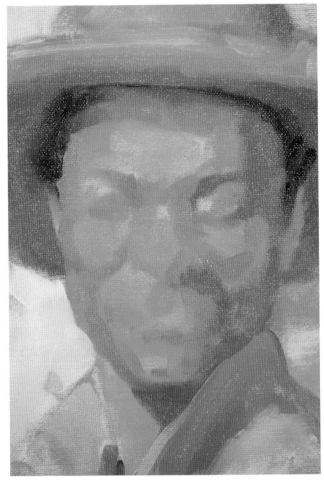

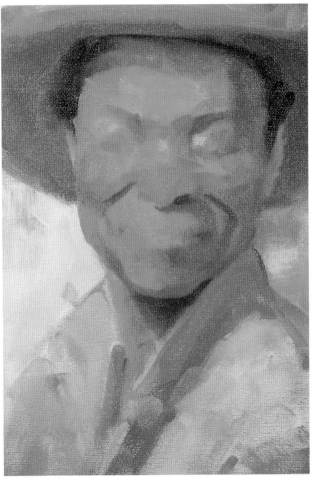

7 **THE HALFTONES**
Starting with the eyes, nose and mouth areas block in the middle-value shapes with Cadmium Red Light, Cadmium Orange, Raw Umber and white. Next move to the lighter value shapes using Cadmium Orange, Burnt Sienna and white.

8 **BUILDING FEATURES**
Build up the forms around the mouth starting with the darks using a mixture of Burnt Umber, Cadmium Orange, Alizarin Crimson and white. The darkest shapes in this area are achieved by adding more Burnt Umber and Alizarin Crimson to the mixture. The lighter darks contain less Burnt Umber and Alizarin Crimson and more Cadmium Orange and white.

Also add a light warm tone to the nose and cheeks using Cadmium Orange, Alizarin Crimson and white.

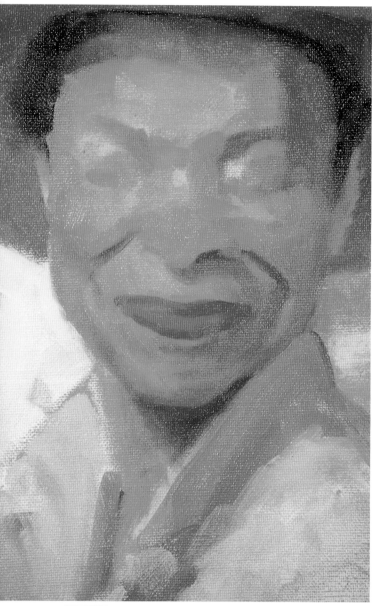

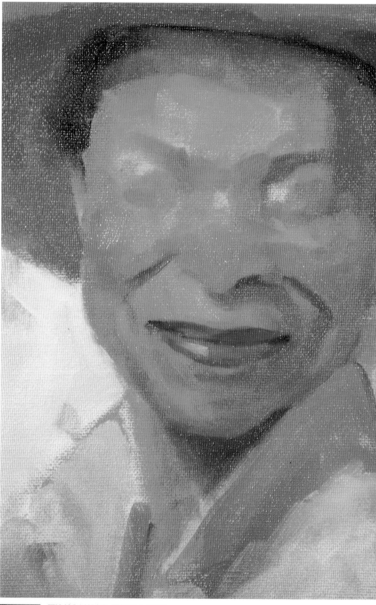

 9 **THE LIPS**
Squinting allows me to see the shape of upper and lower lips as one form. Paint this shape using a cool mixture of Alizarin Crimson, Burnt Umber and white. As I open my eyes a little more, I can see that within the overall shape of both lips, the lower lip is lighter and warmer. Add Cadmium Red Light and white to the above mixture and start to paint in the shape of the lower lip.

After completing the lower lip, redefine the halftones under the lips and chin.

10 **FINISHING THE LIPS**
Using Alizarin Crimson, Burnt Umber and a little white, I paint in the dark lines between the lips. Add a bright highlight on the lower lip using Cadmium Red Light with lots of white.

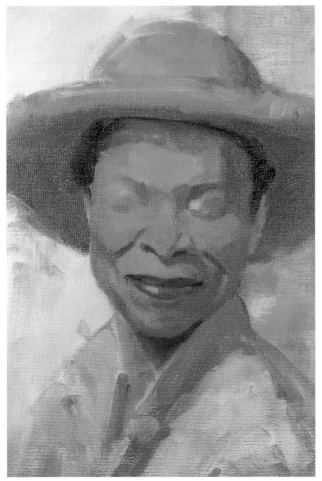

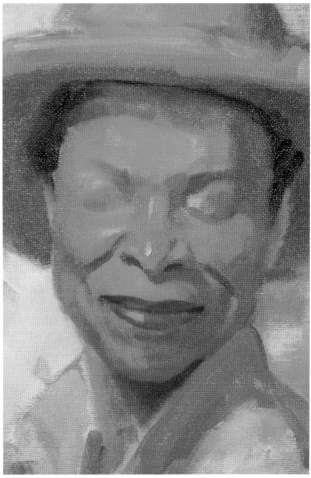

11 **THE NOSE**
There's a nice middle tone on the nose at this point, so we'll continue to build the forms of the nose by starting with the lighter shapes followed by the darks. Paint in the light areas with a mixture of Cadmium Orange, Cadmium Yellow Light, Alizarin Crimson and white. The darker notes are added using Burnt Umber, Cadmium Orange, Alizarin Crimson and white.

At this stage the nostrils can be painted in. For the shadow side, use a mixture of Burnt Umber, Alizarin Crimson and a little white. The nostril on the light side is warmer, so use a little more Cadmium Orange in the above mixture.

12 **THE HIGHLIGHTS**
For the highlights, mix Cadmium Orange, Cadmium Yellow Light and lots of white. Using this mixture and a no. 4 filbert, paint the highlights on the end of the nose with one quick but accurate stroke. Notice the highlights on the wing of the nose and the cheek are not as bright as on the tip of the nose. Add a little more Cadmium Orange and Cadmium Yellow Light to the above mixture for these areas.

TIP

Hold your brush by the end of the handle when you paint, using the same grip as when you hold a barbecue spatula. Use your arm and body, not just your fingers. This forces you to stand at arm's length from your painting, giving you a better perspective and preventing overly detailed work from happening too soon.

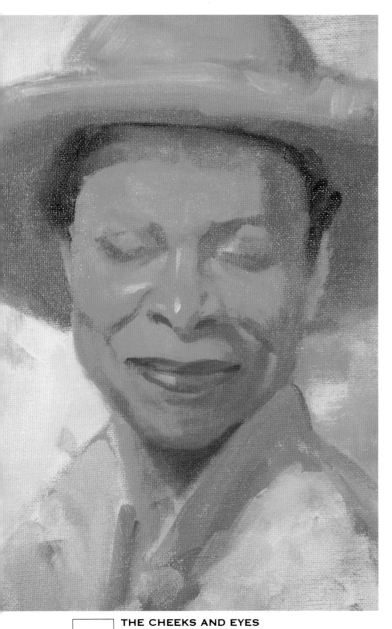

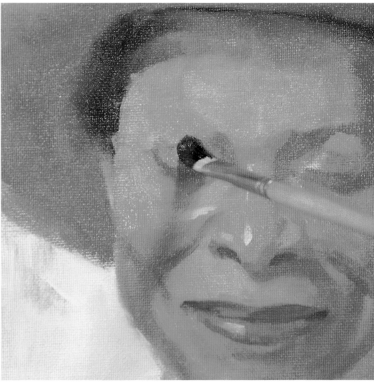

14 **THE IRIS**
Using a no. 4 filbert and a mixture of Burnt Umber and Venetian Red, place an iris into position by slowly twirling your brush. This usually produces a perfect circle.

13 **THE CHEEKS AND EYES**
Using a mixture of Alizarin Crimson, Cadmium Orange and white, I redefine the cheek areas. The dark shapes around the eyes are made up of Alizarin Crimson, white and a touch of Burnt Umber.

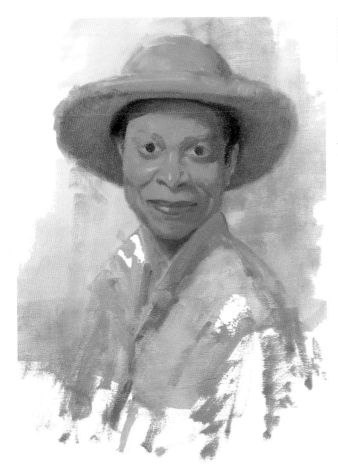

15 **THE EYES AND UPPER SHADOWS**
In this instance the whites of the eyes are for the most part cool. Use white with a little Raw Umber for the light side. Increase the amount of Raw Umber for the shadow side. Add more darks around the eyes and up toward the eyebrows.

Let's take a break from painting the eyes and move up to the forehead shadow areas. Paint these areas with Cadmium Orange, Alizarin Crimson, Burnt Umber and white. Next redefine the hair using Ivory Black and Burnt Umber.

Continuing upward, paint the shadows of the hat with Alizarin Crimson, Burnt Umber, Cadmium Orange and a touch of white. Notice the reflective warm note on the brim of the hat over the forehead. This area is painted with Cadmium Orange, Alizarin Crimson and white.

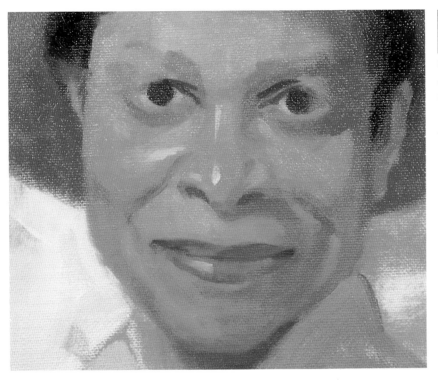

16 **THE EYELIDS**
Moving back to the eyes, paint the portion of the upper lids nearest the nose. Since there are fewer lashes on this portion of the lid, it tends to be warmer in color and lighter in value. Use a mixture of Burnt Umber, Venetian Red and a touch of white.

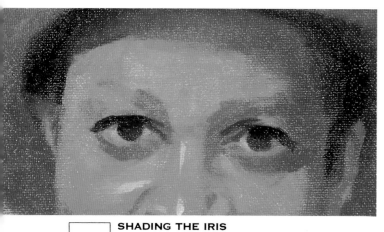

17 **SHADING THE IRIS**
Next, add the darkest part of the upper lids using Burnt Umber, Alizarin Crimson and a touch of Ivory Black. Also add this dark value across the top of the irises to indicate the shadows caused by the upper lids. The lower section of the irises are lightened using Burnt Umber, Alizarin Crimson and Cadmium Orange.

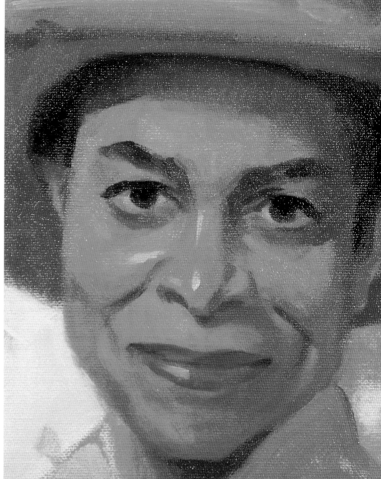

18 **THE PUPILS, EYEBROWS AND DARKS**
Add the pupils using Ivory Black. On the lighter ends of the eyebrows, a mixture of Burnt Umber, Alizarin Crimson, Ivory Black and a touch of white is used. Finally, some dark areas of the face including the shadow side of the nose, the creases under the cheeks and darks under the chin are redefined using a mixture of Burnt Umber, Alizarin Crimson and a little white.

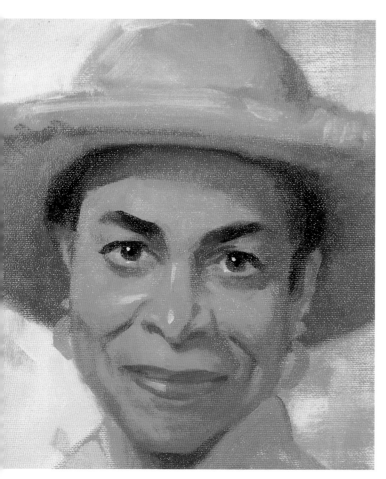

19 **THE EYEBROWS AND HIGHLIGHTS**
The darkest areas of the eyebrows are painted in using Burnt Umber, Ivory Black, Alizarin Crimson and a touch of white. The highlights in the eyes are warm, so use Yellow Ochre, Cadmium Orange and white.
Now paint in the model's right earring using Yellow Ochre, Cadmium Orange and white for the dark halftone area. The earring on the shadow side is darker. Use Raw Sienna, Raw Umber, Cadmium Orange and white.

 COMPLETING THE PORTRAIT

The light halftones come next. For the earring on the light side of the head, use a mixture of Yellow Ochre, Cadmium Orange and white. For the highlight use Cadmium Yellow Light and white. The earring on the shadow side receives a mixture of Yellow Ochre, Cadmium Orange and white.

Finish the portrait by redefining the blouse using a mixture of Cerulean Blue and white for the light areas and Alizarin Crimson, Cadmium Orange, Raw Umber and white for the shadow areas. Complete the hat using various combinations of Alizarin Crimson, Cadmium Orange and white. Add a little Cerulean Blue and white to the background. Lastly, add some cool notes of Cerulean Blue, Raw Umber and white to the shadow side of the face and nose.

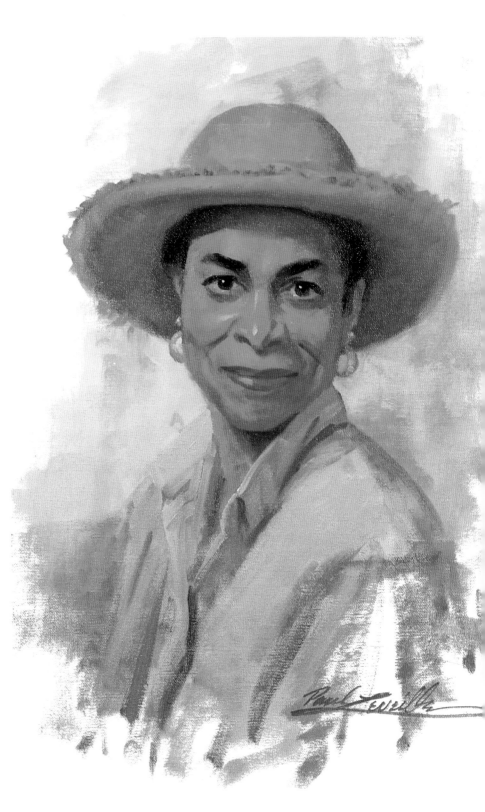

DEMONSTRATION 5
The Fisherman

1 **THE SKETCH**
For this portrait I started with a charcoal sketch on stretched white cotton canvas. Since the head is facing the right side of the canvas, allow a little more "breathing" space on that side. At this point you could continue to refine the charcoal drawing; however, I feel that we have enough information to start in with paint. To prevent your drawing from smudging when paint is applied, spray the drawing with Blair workable fixative.

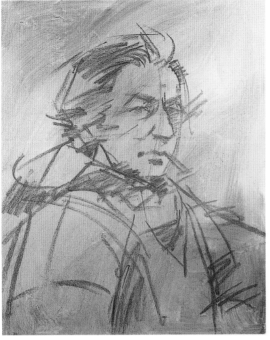

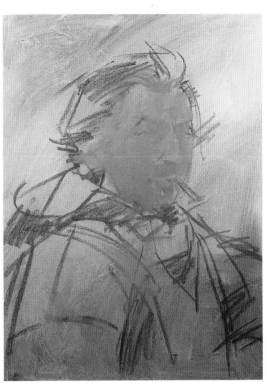

2 **THE WASH**
Once the fixative has dried, apply a wash of turpentine and paint to the canvas using a paper towel (as shown on page 63). Use Cerulean Blue and Cadmium Yellow Light and a second mixture of Alizarin Crimson and Cerulean Blue near the bottom of the canvas.

3 **THE BASIC SKIN TONE**
First mix a ruddy skin tone using Alizarin Crimson, Burnt Sienna, Cadmium Yellow Light and white and scumble it loosely over the face. Next, since the lower portion of the face is darker in value, paint this area with a mix of Burnt Sienna, Raw Sienna, Viridian and white.

4 **THE DARKS**
Using a mixture of Venetian Red, Permanent Green Light, Cadmium Orange and white, paint in the large shadow shapes. Even though there are several color and value changes within the shadow area, we'll use this predominant color and value throughout to keep things simple. As the painting progresses adjustments can be made.

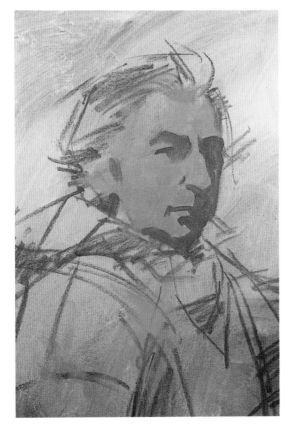

Whenever I mention mixing colors it is always done on the palette, not the canvas. This practice—along with redipping your brush into the paint mixture after only one or two brushstrokes—will help keep your colors clean and crisp.

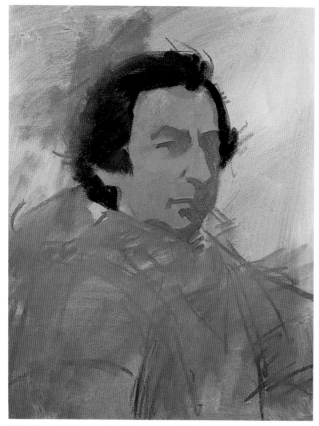

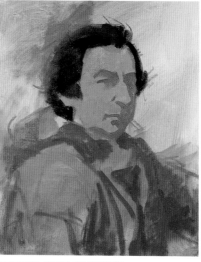

 THE HAIR AND SLICKER

The hair is the next large dark shape. Using a no. 8 filbert, brush in a mixture of Ivory Black, Alizarin Crimson and a touch of white. A little more white and Cerulean Blue is added near the outside top of the hair.

At this point we also want to get the overall brilliant orange tone of the slicker on the canvas, since this bright color will influence the other colors in the painting. Using a no. 10 filbert, loosely paint a mixture of Cadmium Orange, Raw Umber and white over the area of the slicker and into part of the background and hair as well.

6 **THE SLICKER**

Continue on the slicker by painting the darks. You can simplify this task by breaking the darks into two values. The darkest values are painted with Alizarin Crimson, Ultramarine Blue and a touch of Cadmium Orange. The lighter, warmer darks are made up of Cadmium Orange and Alizarin Crimson.

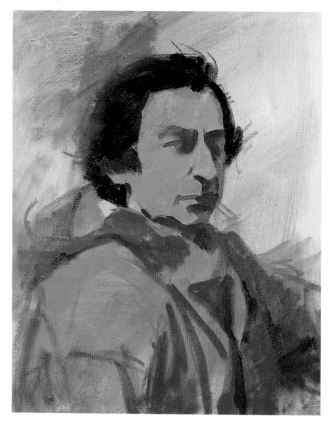

 MORE DARKS

Now that all the large dark shapes are blocked in, I feel some of the areas in the shadows of the face could be darker and warmer. Using a no. 8 filbert, paint the areas of the eye socket, under the nose and under the chin with a mixture of Indian Red and Ultramarine Blue. By adding a little more Ultramarine Blue to the above mixture, you'll get a more purpley dark that you can use for the darkest folds in the slicker.

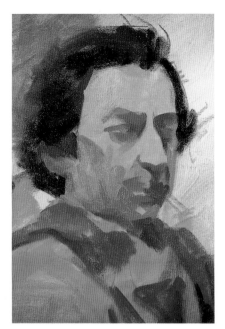

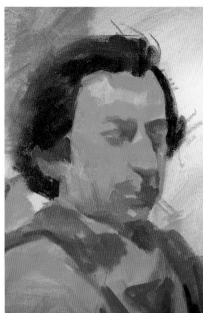

9 THE UPPER FACE

Moving up the face, make the halftone values of the nose and cheek lighter using Cadmium Red Light, Raw Sienna and a touch of Cadmium Yellow Light and white.

The temple area is more golden so use Raw Sienna, Burnt Sienna, Cerulean Blue and white.

8 THE LOWER PORTION OF THE FACE

While squinting at the model, I notice that the halftones on the lower side of the face must get darker in value. Using a mixture of Yellow Ochre, Permanent Green Light, Burnt Sienna and white, paint the lower cheek and neck. Around the chin and mouth a warmer dark of Cadmium Red Light, Yellow Ochre, Permanent Green Light and white is used.

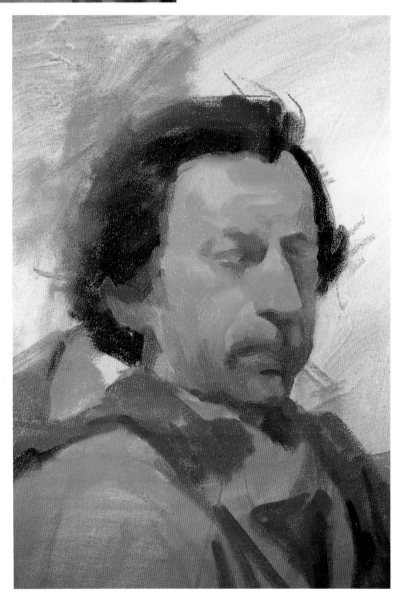

10 THE FOREHEAD AND CHEEK

Using a mixture of Yellow Ochre, Burnt Sienna and white, paint the light areas of forehead and cheek. Start to soften some edges by bringing one color and value area into another. For example, the area between the lips and nose goes from dark near the lips to lighter up near the nose. Start this area by painting the darkest area around the lips first. Make your next mixture a little lighter and warmer and paint that in above the dark area, letting your brush drag lightly into the dark area to "blend" with it. Finally, mix the lightest value and brush it into position letting your brush flow lightly down into the last section painted.

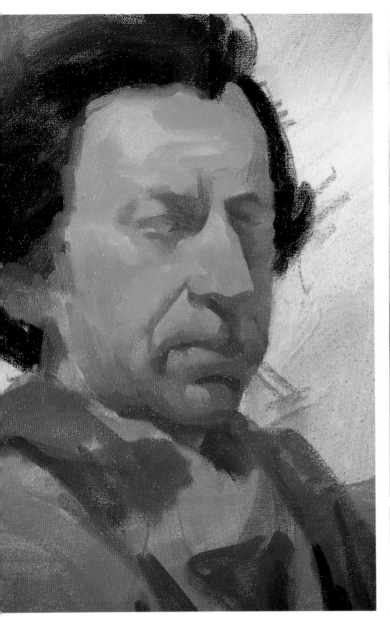

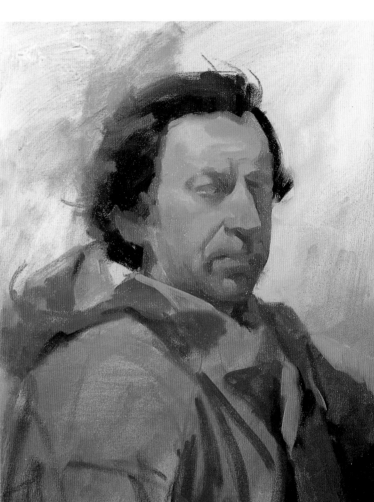

11 THE FEATURES

At this stage I want to focus on building the features. That is, to paint the subtle values and color shapes that will give the illusion of forms that come forward or recede. Start with the mouth area. With a mixture of Venetian Red and Cadmium Orange, paint the "hot" notes under the chin, under the lower lip and under the nose.

Next, using Cadmium Red Light, Cadmium Orange, Raw Umber and white, brush in the light area on the lower lip.

Darken the value of the cool note on the chin using Cerulean Blue, a touch of Venetian Red, Yellow Ochre and white. Also add a warm dark between the skin and hair.

12 THE FEATURES AND BACKGROUND

The upper lip and shadow on the lower lip are painted in with a cool mixture of Alizarin Crimson, Raw Umber, Cadmium Red Light and white. This mixture is also painted in shadow areas of the slicker, in the hair and around the eyes.

Mixing a background color of Cadmium Yellow Light, with a touch of Cerulean Blue, paint alongside the cheek on the shadow side to develop the shape more accurately. While in the background area, mix Cerulean Blue and white on your palette, and add it to the background as well as some spots on the slicker. This part of the demonstration is a good example of how to move a color around the painting to achieve a desirable design and rhythm. I do this mostly by feel.

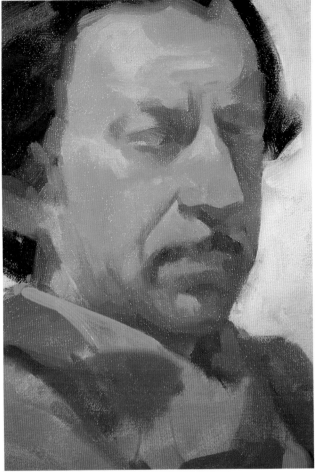

13 **THE MUSTACHE**
Start by painting the dark area of the mustache with a mixture of Burnt Umber and Ultramarine Blue. Using downward strokes (the direction in which the mustache hairs grow), paint the lighter values using Raw Umber, Cerulean Blue and white.

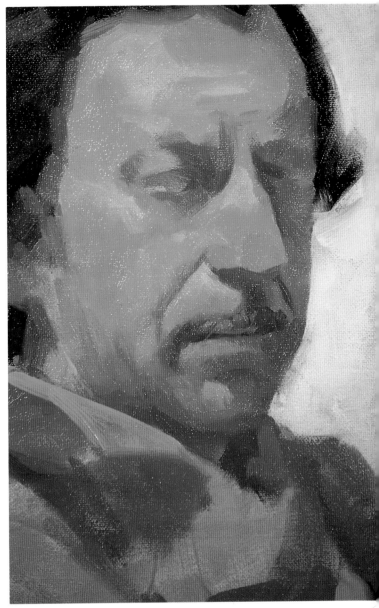

14 **THE MUSTACHE AND LIPS**
Using a no. 4 filbert, paint in the dark line between the lips using a mixture of Alizarin Crimson and Burnt Umber.

Next, add a few light hair sections to the mustache using Raw Umber, white and a little Yellow Ochre.

TIP

Occasionally you will see that I add a touch of white to dark mixtures. Some mixtures are so dark that it is hard to discern the color. Adding a "touch" of white to the mixture will bring out the color as well as the temperature (warm or cool).

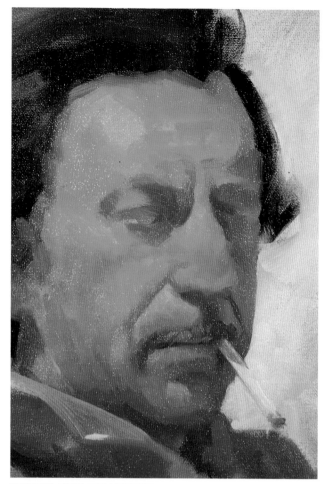

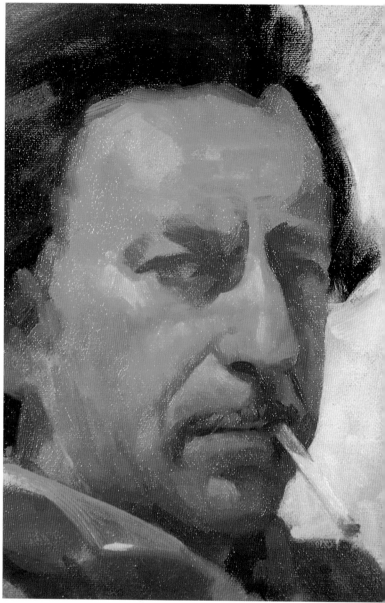

THE CIGARETTE

15 Before painting the cigarette, clean up the background area behind it with a mixture of Cadmium Yellow Light, Cadmium Orange, white and a little Cerulean Blue. Also add some of this color to the slicker and back of the head.

Next, add the shadow portion of the cigarette using Cerulean Blue, Raw Umber and white. The light section of the cigarette is painted in using white with a touch of Yellow Ochre. For the ash on the tip of the cigarette, use Raw Umber, white and a touch of Cerulean Blue. In addition, add a warm note to the underside of the cigarette shadow using Cadmium Orange, Yellow Ochre and white.

Add more ruddiness to the nose, cheek and forehead using Alizarin Crimson, Raw Sienna, a touch of Cadmium Orange and white.

THE NOSE

16 A cooler mixture of Alizarin Crimson, Cerulean Blue, a touch of Raw Sienna and white is painted on top of the nose. A lighter mixture of Raw Sienna, Cadmium Orange and white is brushed on the bridge and wing of the nose. Next, add the dark nostrils using Burnt Umber, Alizarin Crimson, a touch of Cadmium Orange and white.

The highlights go on next and are a cool mixture of white, Cadmium Orange and Cerulean Blue. Also move a little of this cool highlight to the cheek area. Finally move up to the eyes and add some darks using Alizarin Crimson, Burnt Umber and a touch of Cadmium Orange.

17 THE EYES

Using Burnt Umber, paint in the irises and the upper lids.
Some shadows are redefined using Burnt Umber, Alizarin Crimson and Cadmium Orange. The whites of the eyes are not receiving direct light and are fairly dark in value; however, they will still appear light because they are surrounded by darks. Use a mixture of Burnt Umber, Alizarin Crimson and white.

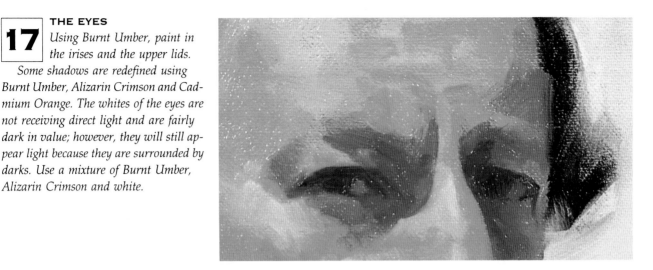

18 THE EYEBROWS AND HAIR

The darks of the eyebrows are added using Burnt Umber and Alizarin Crimson. Use white and Cerulean Blue for the lighter cool areas on the tops of the brows. The hair on the shadow side of the head is redefined using Ivory Black and Alizarin Crimson.

Using a no. 10 filbert, redefine the large dark areas of the hair using Ivory Black and Alizarin Crimson. Follow this by using a clean no. 10 filbert to add the lighter values with a cool mixture of Burnt Umber, Cerulean Blue and white. Also add some Cadmium Orange to the mixture on the hair near the ear to serve as reflected light from the slicker.

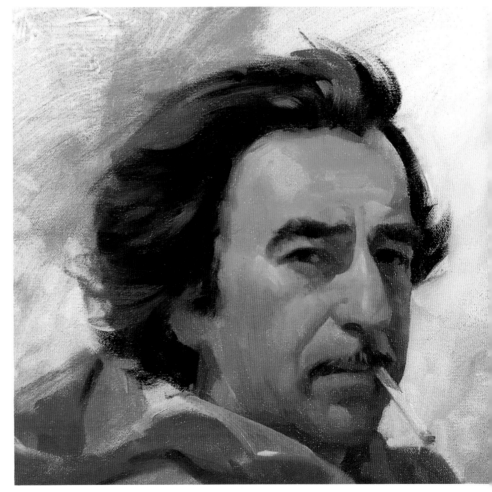

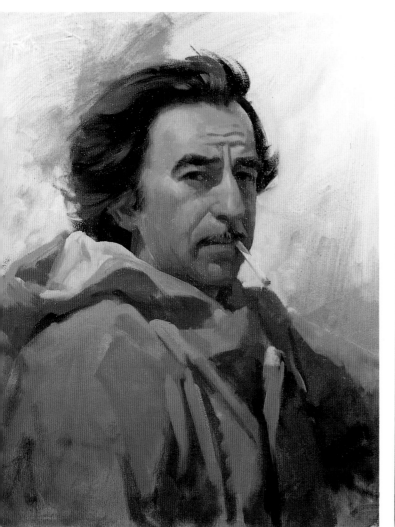

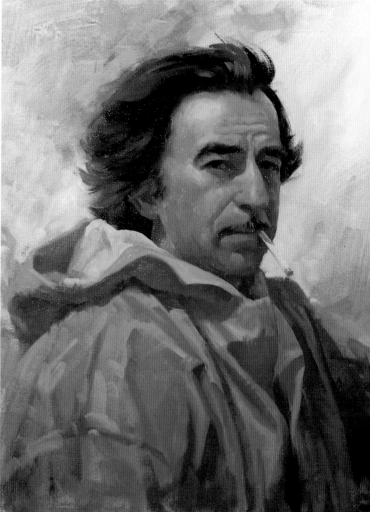

 THE TOUCH-UPS

To complete the ear, paint the dark areas using Alizarin Crimson, Burnt Umber and Cadmium Orange. The light areas are a mixture of Cadmium Orange, Alizarin Crimson and white.

Next, add more color to the slicker using the light area mixture above. However, use less Alizarin Crimson and more Cadmium Orange for a brighter color. For the light areas in the hood of the slicker, use white and Yellow Ochre. For the shadows use Cadmium Orange, Raw Umber and white.

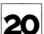 **THE SLICKER AND FOREHEAD**

To better define the creases in the forehead, they will have to be made up of three values—dark, halftone and light. Since the darks are already in place, I will add warm halftones above the darks using Burnt Sienna, Cadmium Orange and white. For the light areas below the darks, I use Cerulean Blue and a touch of Cadmium Orange and white. Next, I add the highlights on the forehead, using lots of white with a little Cadmium Orange and a touch of Cerulean Blue.

Moving down the jacket, I start with the darks. A mixture of Cadmium Orange, Alizarin Crimson and white is used. I add some cool notes to the slicker using Cerulean Blue, a touch of Cadmium Orange and white. I also bring oranges and blues into the background. Finally, I add some lights to the slicker using a mixture of Cadmium Yellow, Cadmium Orange and white.

COMPLETING THE PORTRAIT

21 *I add the slicker hood using a mixture of white, Cerulean Blue and Raw Sienna. Next, I paint the buttons using three values. First I use Burnt Sienna and Permanent Green Light for the halftone. Next, a mixture of Alizarin Crimson and Burnt Umber is used for the dark center. For the first step, I used white and Cerulean Blue for the highlights. I finish up by adding highlights to the eyes. These highlights are from reflective light, not direct light—so they are quite dark. I used a mix of Cerulean Blue and Raw Umber.*

DR. WILLIAM KAPLAN,
34" × 33" (86.4cm × 83.8cm)

The way your subject is dressed can give the viewer an insight into the subject's character. These two portraits, along with the previous demonstration, reveal the sitter's occupation.

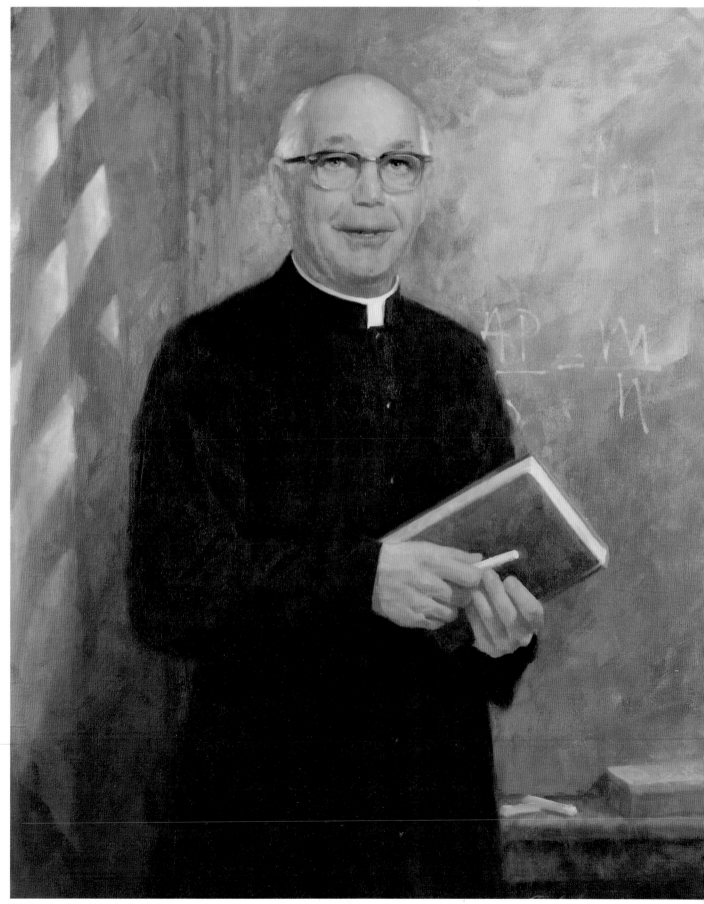

FATHER CASELLI, 34" × 26" (86.4cm × 66cm)

DEMONSTRATION 6
Young Boy With Blond Hair

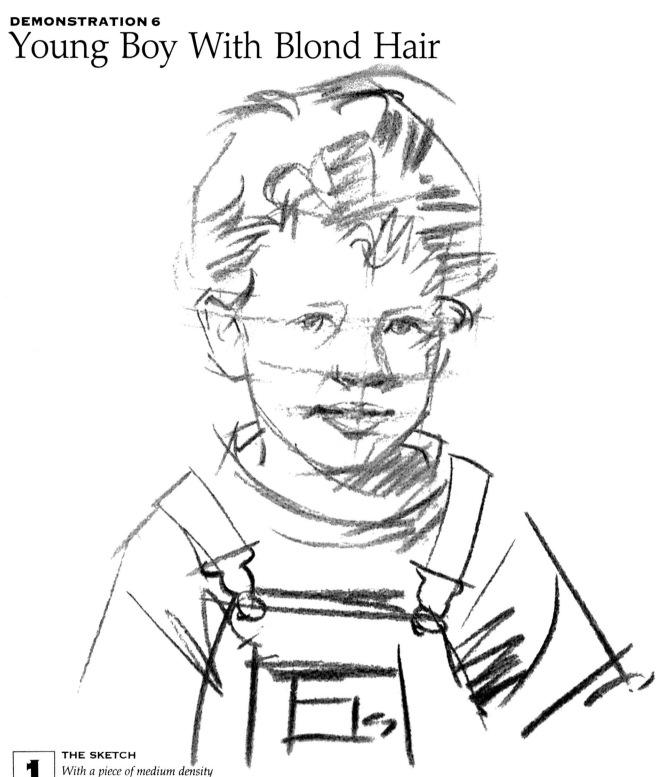

1 **THE SKETCH**
With a piece of medium density vine charcoal, sketch the head on white cotton canvas. At this time I'm not interested in details, my goal is to capture the tilt of the head and the position of each of the features. Once this is accomplished, the sketch is sprayed with workable fixative to prevent smudging when the paint is applied.

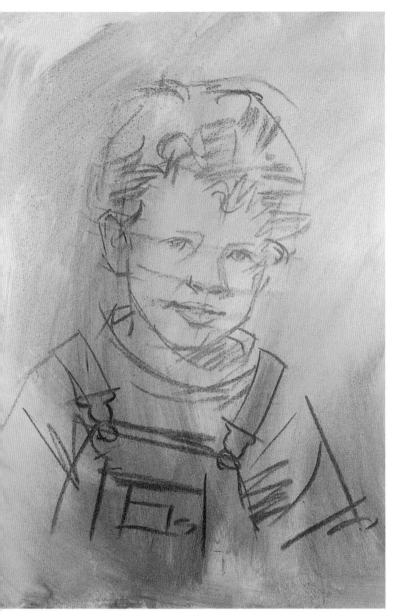

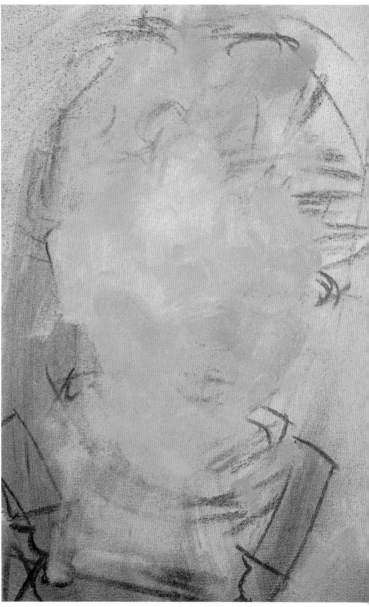

 THE WASH
Rather than having the rich blue of this little boy's overalls isolated to one area, I decide to move some of this color throughout the painting. A paper towel is used to spread a wash of Ultramarine Blue, a little white and lots of turp over parts of the canvas. A clean paper towel is used to apply a second wash of Yellow Ochre and turp.

 THE SKIN TONE
Selecting a general color and value from the light side of the face, use a no. 10 filbert to scumble a light mixture of Cadmium Red Light, Yellow Ochre, a little Cerulean Blue and white over the sketch of the face. A little more Cadmium Red Light and Yellow Ochre is added to the mix and scumbled over the cheeks, nose and ear. The lower section of the face is slightly darker in value. Paint this area with a mixture of Raw Sienna, Burnt Sienna, white and a touch of Cadmium Orange. This mixture is also applied to the temples and the neck. To achieve some of the lighter areas, simply use a clean paper towel to wipe some paint from the forehead and cheek areas.

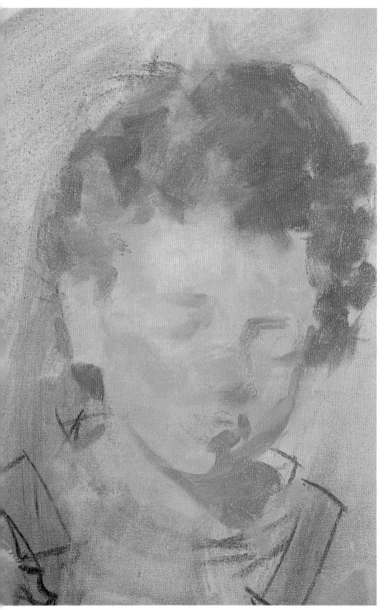

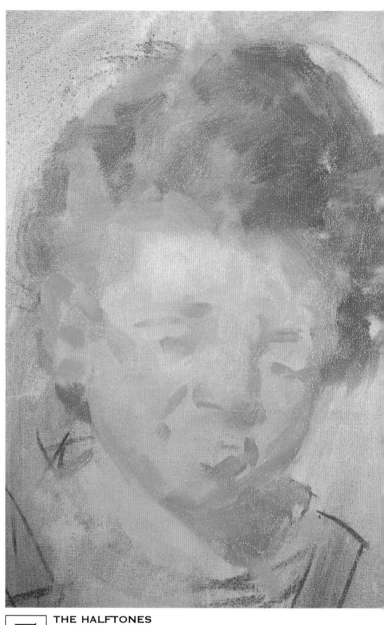

 THE DARK SHAPES
While squinting at the model, I look for the big dark shadow shapes. Using a no. 6 filbert, paint them in along the side of the nose, side of the head, under the chin and lips. A mixture of Raw Umber, Raw Sienna, Burnt Sienna and white is used. Next, the big dark shapes of hair are painted in using Burnt Sienna, Burnt Umber, Permanent Green Light and white.

5 **THE HALFTONES**
Moving back to the face, mix a warm halftone color of Cadmium Red Light, Burnt Sienna and white and paint the chin, under the eyes, the temple and the ear. A lighter mixture of Cadmium Red Light, Cadmium Yellow Light and white is used on the cheeks and nose.

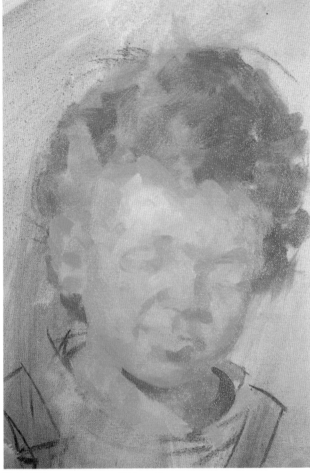

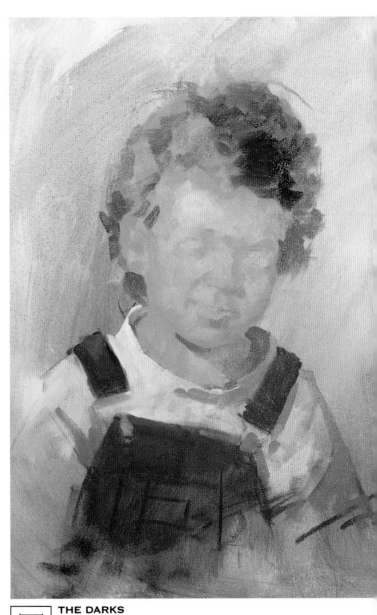

6 **MORE HALFTONES**
Still concentrating on halftones, mix Cadmium Red Light, Yellow Ochre, Burnt Sienna and white for the forehead, nose, lower cheek and chin area. Using a light mixture of Cadmium Red Light, Yellow Ochre and white, paint the area under the nose. Also, the neck and forehead receive a golden color of Raw Sienna, Cadmium Red Light and white.

7 **THE DARKS**
The biggest dark shape is the overalls. Paint them in using a mixture of Ultramarine Blue, Alizarin Crimson and a touch of white. The white shirt is a mixture of white with a little Yellow Ochre. Add a few darks to the hair using Burnt Umber and Cadmium Orange.

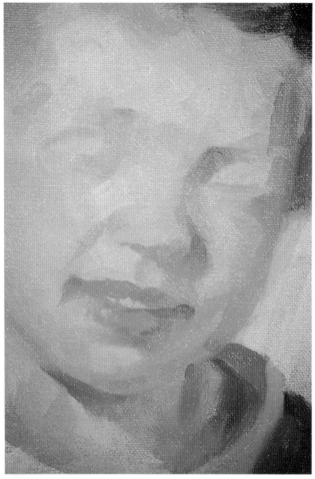

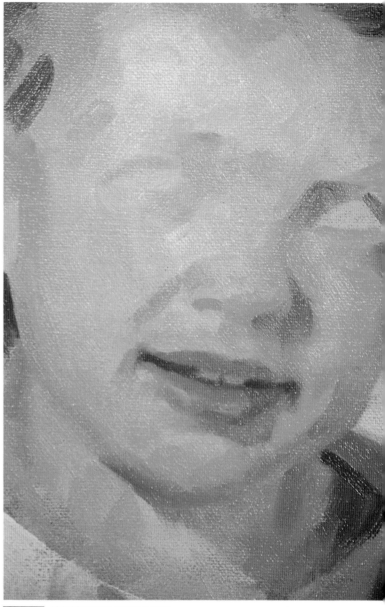

8 **THE LIPS**
Moving back to the face, I decide to start the mouth area. Paint the light areas of the upper and lower lips with a mixture of Cadmium Red Light, Raw Umber and white. A lighter mixture of Cadmium Red Light, Yellow Ochre and white is used on the left side of the lower lip as it flows down into the light skin area.

Next, go for the dark shapes on the lower lip using Cadmium Red Light, Alizarin Crimson, Raw Umber and white. The dark shadow in the corner of the mouth is made up of Venetian Red, Permanent Green Light and a touch of white. Paint the shadow around the nose a little darker and warmer by using a mixture of Venetian Red, Raw Umber, Cadmium Orange and white. The shadow on the side of the nose and the eyebrow area is strengthened by using Venetian Red, Permanent Green Light, Raw Sienna and white.

9 **FINISHING THE LIPS**
Finally, with a no. 4 filbert, paint the darks between the lips using Burnt Umber and Cadmium Red Light. For the teeth a mixture of Raw Umber, Raw Sienna and white is used. The highlights go on last. A mixture of Cadmium Red Light and lots of white is used.

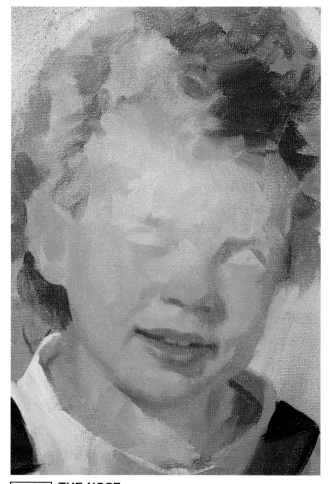

10 **THE NOSE**
*Moving up to the nose, add a
warm halftone of Cadmium Red
Light, Raw Sienna and white over the bulb
of the nose, the ear and the hairline area
of the forehead. The greenish shadow on
the bottom of the nose is a mixture of Burnt
Sienna, Permanent Green Light and
white.*

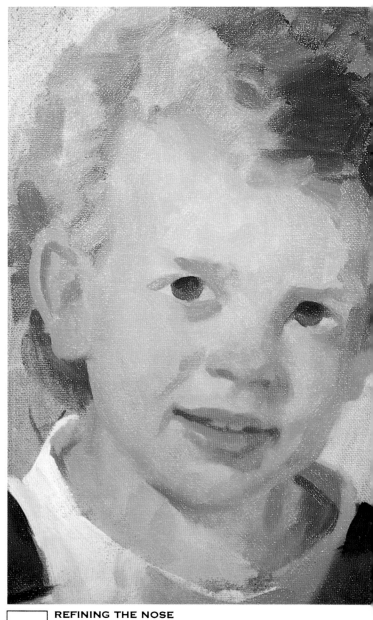

11 **REFINING THE NOSE**
*Once the basic shape of the nose
is established through light and
dark shapes, paint the nostrils in using a
warm dark mixture of Burnt Umber, Cad-
mium Red Light and a touch of white.
Add more pink tones of Cadmium Red
Light, Burnt Sienna, Yellow Ochre and
white to the cheeks. The light tones on the
forehead and cheeks are a mixture of Cad-
mium Red Light, Cadmium Yellow Light
and white.*

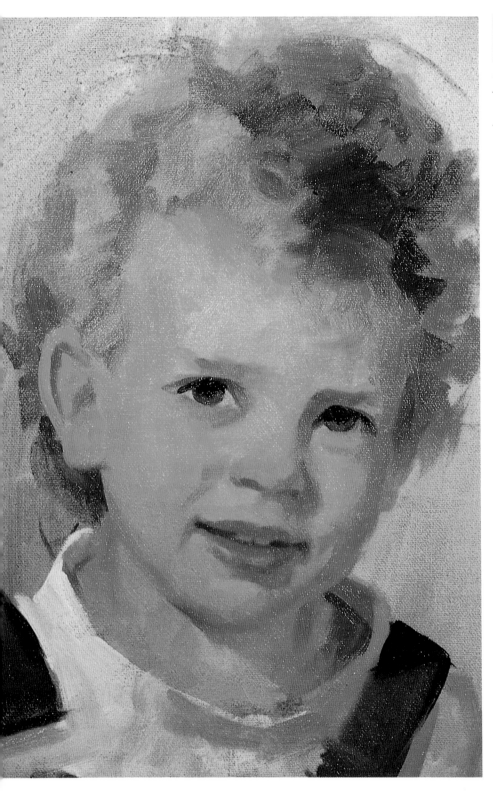

12 **THE EYES**
Using a dark mixture of Burnt Umber and Cadmium Orange, paint the irises in by "twirling" a no. 4 filbert to make clean circular shapes. The upper portion of the irises are in shadow from the upper lids. Paint this shadow area with a mixture of Burnt Umber and Cadmium Red Light. The warm halftones around the eyes are painted in using Burnt Sienna, Cadmium Red Light, Raw Sienna and white. The ear receives some light pink tones of Cadmium Red Light, Cadmium Orange and white. The warm darks are made up of Cadmium Red Light, Raw Sienna and white.

 FINISHING THE EYES

Getting back to the eyes, paint the dark lashes over the eyes using Burnt Umber. The warmer, lighter lid areas are Burnt Umber, Cadmium Red Light and a touch of white. Strengthen the eyebrow and shadow area on the side of the nose with a mixture of Burnt Sienna, Permanent Green Light and a touch of white.

The eyebrow on the light side is a warmer mixture of Cadmium Red Light, Raw Sienna and white. The whites of the eyes are usually not solid white, and this model is no exception. Paint the whites of the eyes in with a mixture of Raw Umber and white.

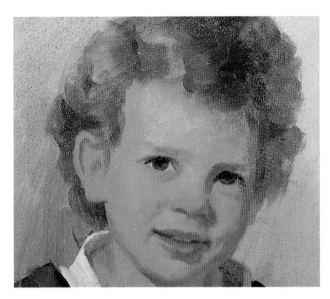

THE HAIR

Use a no. 8 filbert to paint the big middle-value halftones using a mixture of Burnt Sienna, Permanent Green Light and white. The dark areas are added using a mixture of Viridian, Cadmium Red Light and white. The lightest areas of the curls are painted in with a no. 10 filbert using a mixture of white, Yellow Ochre, Burnt Sienna and Cadmium Yellow Light.

I use the following technique, starting in the dark area, to soften the light areas on the curls. I "pull" a brush loaded with a dark mixture into the light area and lift. To prevent "mud" on my painting, I take care to pick fresh paint from my palette before each additional stroke. Highlights are added to the nose and eyes using a light mixture of Yellow Ochre and white. The bright areas of the cheek and forehead are lightened with a mixture of Cadmium Red Light, Yellow Ochre and white.

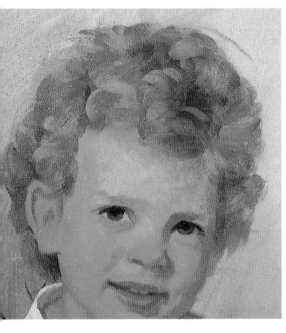

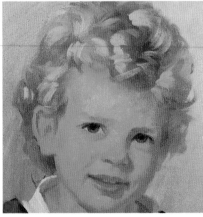

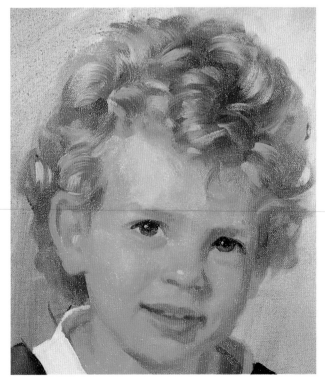

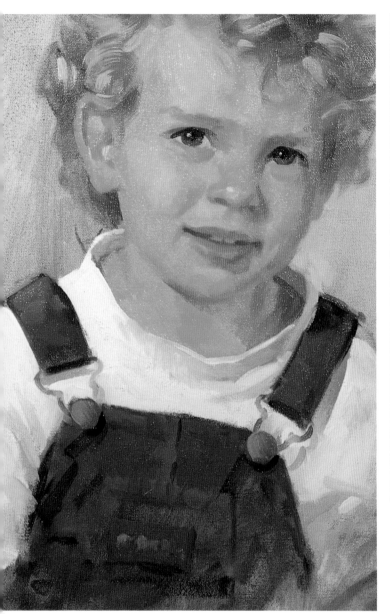

16 **THE HIGHLIGHTS**
Finally, I add the highlights to the buttons and clips with a mixture of Yellow Ochre and white. The finished portrait is shown at right.

15 **THE CLOTHING**
Although the shirt is white, it has a warm tint to it. Use white with a touch of Yellow Ochre. Redefine the shadows of the shirt using a mixture of Ultramarine Blue, Alizarin Crimson, white and a little Raw Sienna.

The dark blue overalls are painted with a mixture of Ultramarine Blue and Ivory Black, with a touch of white and Alizarin Crimson. To start the brass buttons and clips, paint in the dark shapes with a mixture of Viridian and Cadmium Orange. Next, paint a halftone color made up of Yellow Ochre, Burnt Sienna and white on the buttons and clips.

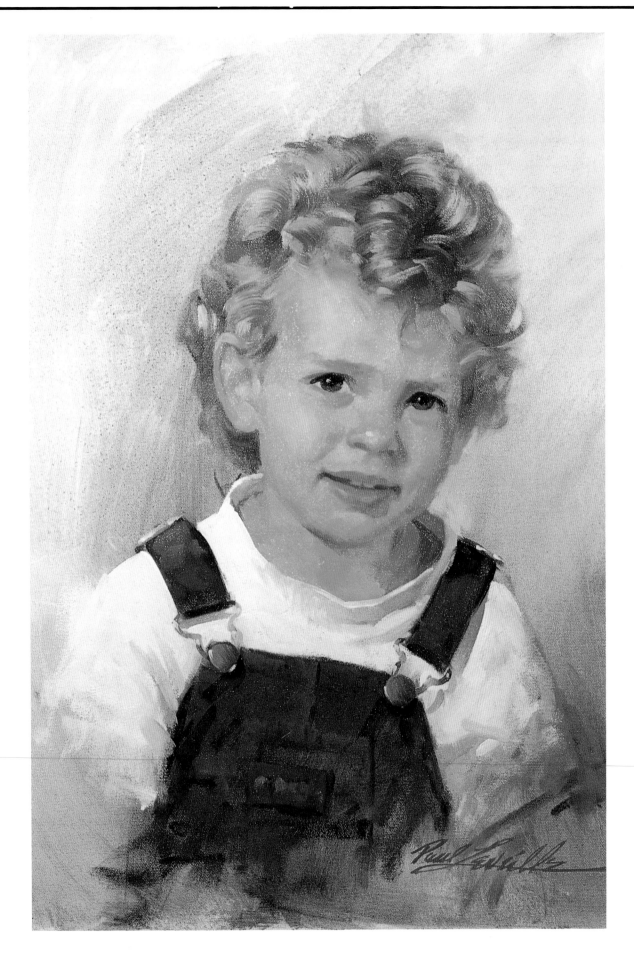

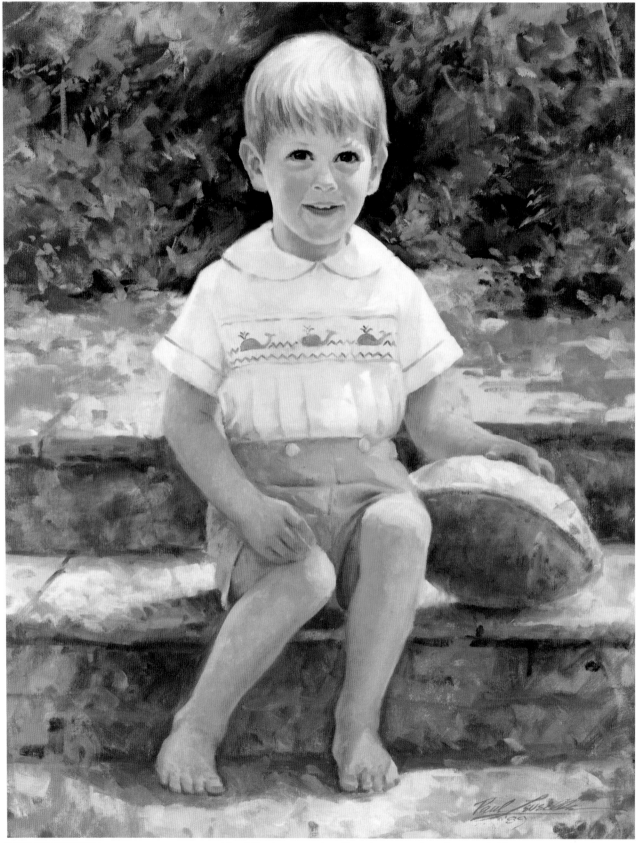

PARKER RICHEY,
32" × 24" (81.3cm × 61cm)

The following portraits offer other examples of young children. Notice that the group portrait on page 112 has a more formal feel. The technique is the same for a formal portrait, I just continue developing the details to a finer degree.

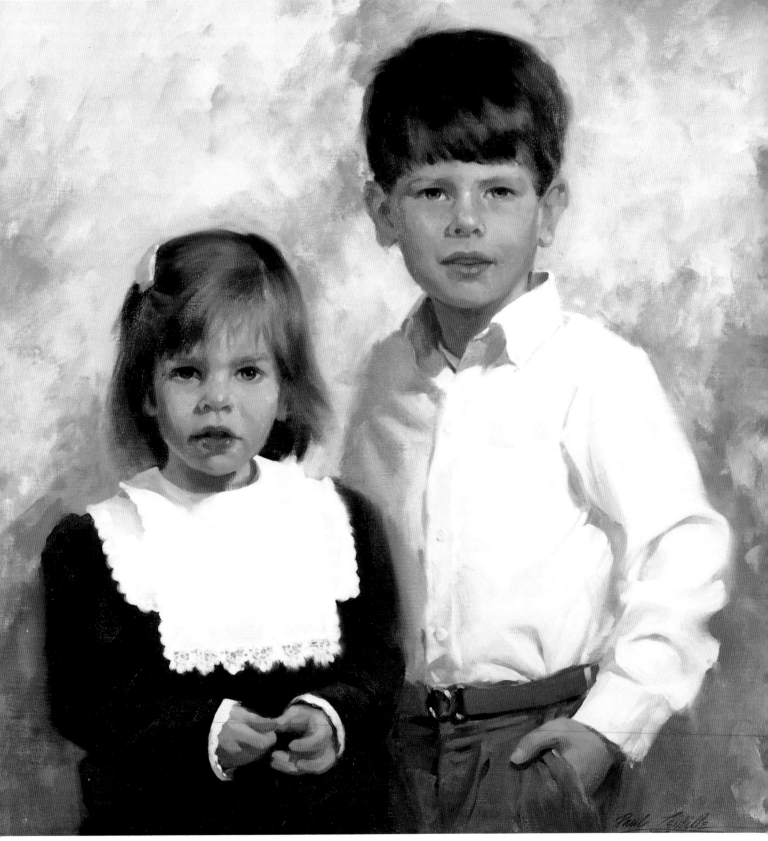

KATE AND PATRICK CLAYTON,
28" × 28" (71.1cm × 71.1cm)

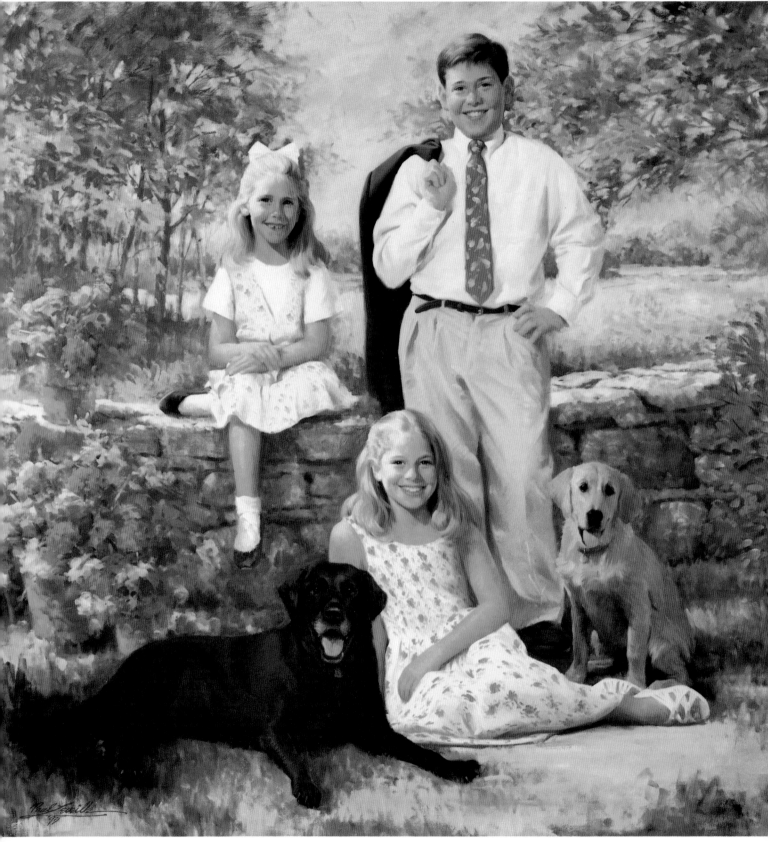

THE TAKVORIAN CHILDREN, *58" × 60"* *(147.3cm × 152.4cm)*

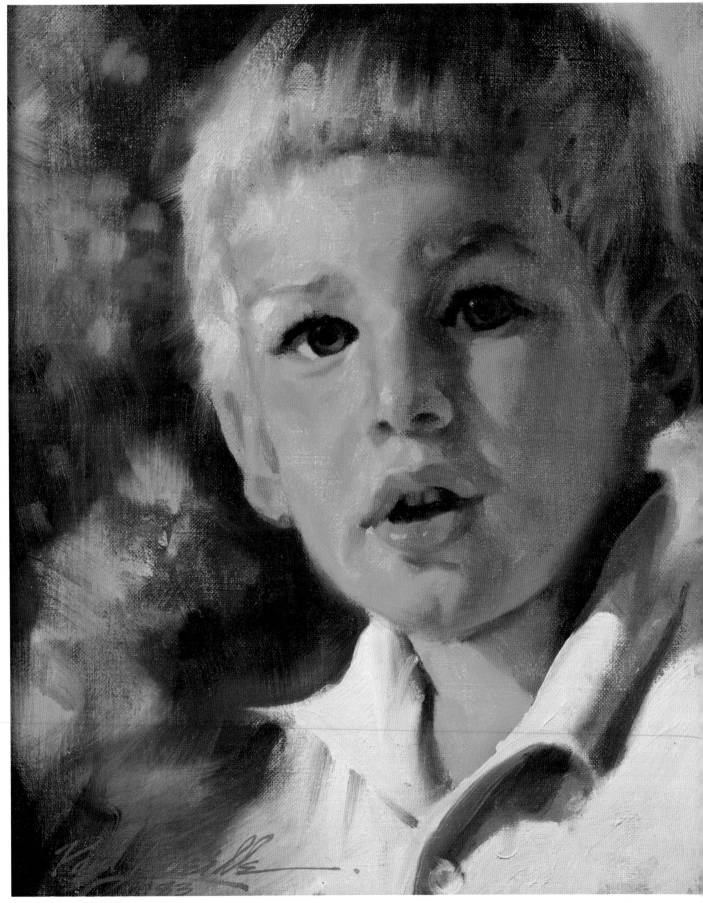

P.J. MOYNIHAN, *14″ × 11″ (35.6cm × 27.9cm)*

DEMONSTRATION 7
Korean Girl

> ### TIP
>
> When sketching with paint it is very easy to make corrections. Simply dip a portion of paper towel in turp, then wipe away undesired paint strokes. Now you're ready to start fresh.

1 **THE SKETCH**
With a more spontaneous approach, I start this portrait of a young girl by sketching directly with paint on white canvas. With a no. 8 filbert, apply a light purple mixture of Ultramarine Blue, Alizarin Crimson, white and a touch of Cadmium Red Light. Brush marks for the top of the head and chin are my first strokes, used to indicate the position of the head on the canvas. Next, vertical strokes indicate the sides of the head, followed by the feature guidelines and shoulders.

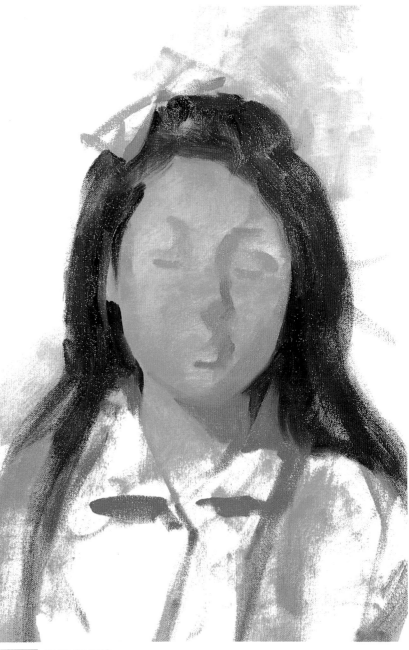

 THE BASIC SKIN TONE
To cover the white canvas, scumble a mixture of Burnt Sienna, Yellow Ochre, Cadmium Red Light and white over the face, arms and some of the background using a no. 10 filbert. I use very little medium with my paint at this point. Too much medium would cause the paint to be slippery, making it difficult for additional layers of paint to adhere to the canvas.

A darker value of the same mixture (less white) is applied to the upper forehead. To achieve the light areas of the forehead and cheeks, use a clean paper towel to wipe some of the paint away. Add a little pink to the cheeks and nose using a mixture of Cadmium Red Light, Burnt Sienna, Yellow Ochre and white.

3 THE DARKS
By squinting at the model, I can eliminate all the subtle value changes and view the shadow areas as simple dark shapes. Use a mixture of Cadmium Red Light, Ultramarine Blue and white for the shadow shapes along the cheek, nose and lips. The shadows for the lighter areas of the upper side of the nose and cheek are warmed up by adding Cadmium Orange to the mixture.

Use a no. 10 filbert for the large dark shapes of the hair using a mixture of Burnt Umber and Ultramarine Blue. The warm halftones are a mixture of Burnt Umber, Cadmium Red Light, Yellow Ochre and white. For the cool shadows on the blouse, use Alizarin Crimson, Ultramarine Blue and white.

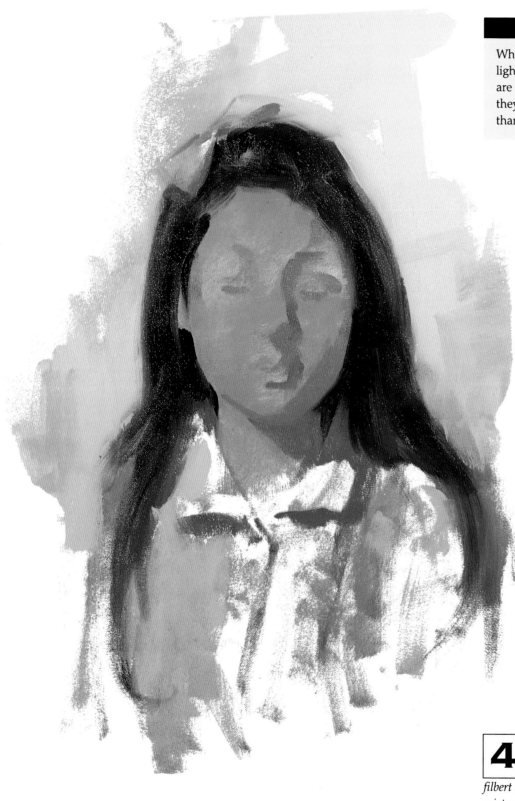

TIP

When painting areas of reflected light, keep in mind that since they are surrounded by dark shadows, they often appear to be lighter than they really are.

THE BACKGROUND
I want this portrait to have a bright, airy feeling. Use a no. 10 filbert and add some cool notes that are a mixture of Cerulean Blue, white and a touch of Cadmium Yellow Light. Next add the warmer notes that are made up of Cadmium Yellow Light and white.

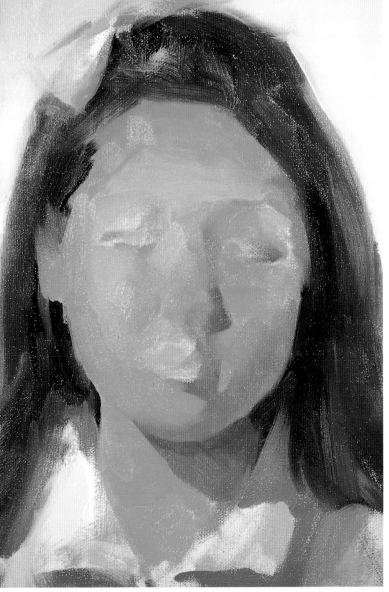

 THE SHADOWS

Darken the neck shadow using Venetian Red, Ultramarine Blue, Cadmium Red Light and white. The chin and lower cheek of the shadow side receive a mixture of Venetian Red, Yellow Ochre, Cadmium Orange and white. A warmer tone of Cadmium Red Light, Venetian Red, Yellow Ochre and white are painted on cheeks and nose. On the light side of the face, paint the chin with a warm tone of Raw Sienna, Cadmium Red Light and white. Variations of this mixture are used on the cheek and forehead.

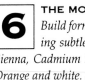 **THE MOUTH AREA**

Build form in this area by painting subtle halftones of Raw Sienna, Cadmium Red Light, Cadmium Orange and white. A reflected light under the chin is put in using Yellow Ochre, Venetian Red and white.

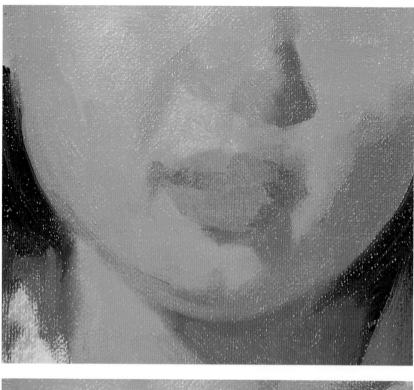

7 **THE LIPS**

Now that I have shaped the mouth area through values and color, I can start on the lips. Paint in the overall shapes of both lips with a no. 6 filbert using a mixture of Cadmium Red Light, Cadmium Orange and white. Mix a slightly darker mixture of Cadmium Red Light, Raw Umber, a touch of Alizarin Crimson and white for parts of the upper and lower lips. The side of the lower lip and corners receive a warm dark mixture of Cadmium Red Light, Alizarin Crimson, Raw Umber and white. The shadow under the lower lip is redefined using Raw Sienna, Venetian Red and a touch of white.

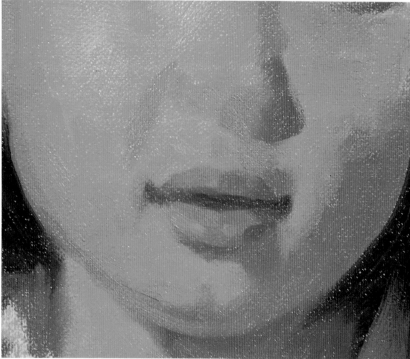

8 **FINISHING THE LIPS**

Finally, paint the warm dark area between the lips with Burnt Umber and Cadmium Red Light. The highlights are added using a mixture of white, Cadmium Red Light and Cadmium Orange.

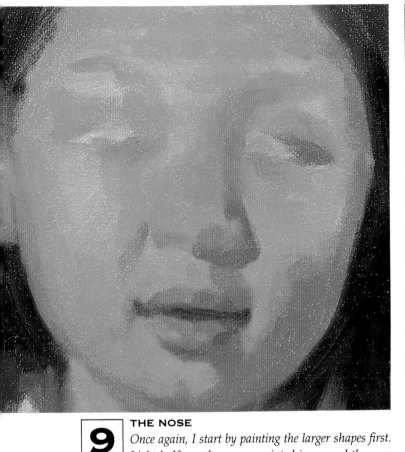

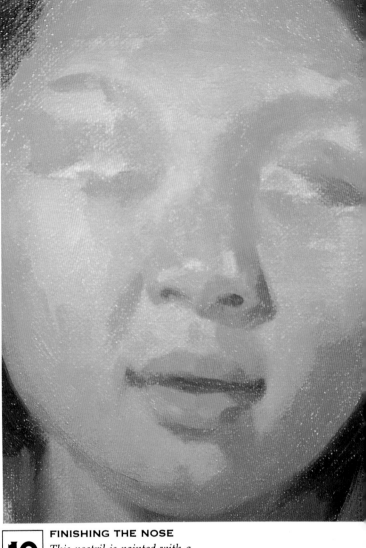

THE NOSE

9 Once again, I start by painting the larger shapes first. Light halftone shapes are painted in around the nose area using a mixture of Cadmium Red Light, Burnt Sienna, Raw Sienna and white. For the dark shapes under the nose, add more Cadmium Red Light and Burnt Sienna to the mixture. This mixture with some variations works well for other areas of the face including around the eyes and forehead. It is also used to soften the shadows on the upper portion of the nose and eyebrow.

Redefine the strong shadow on the side and under the nose using Ultramarine Blue, Alizarin Crimson and white. In areas where the shadow receives more light, the shadow mixture is warmed by adding a touch of Cadmium Orange. Apply a mixture of Cadmium Red Light, Burnt Sienna, Raw Sienna and white to the bridge of the nose. Notice how I move the stroke across the bridge of the nose rather than down. This adds more interest to the painting.

FINISHING THE NOSE

10 This nostril is painted with a warm dark mixture of Burnt Umber and Cadmium Red Light. The dark nostril area on the light side of the face is warmer because light is penetrating the wing of the nostril. The nostril on the shadow side is darker and has more Burnt Umber in the mixture. Add the highlights on the nose using a mixture of Yellow Ochre, Cadmium Red Light and lots of white.

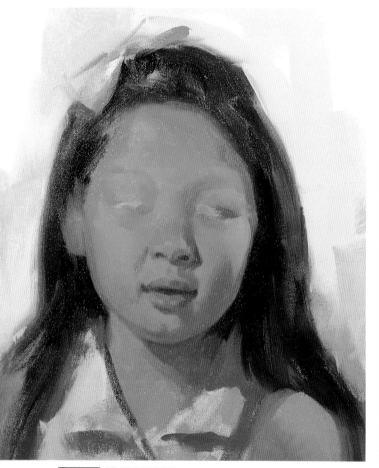

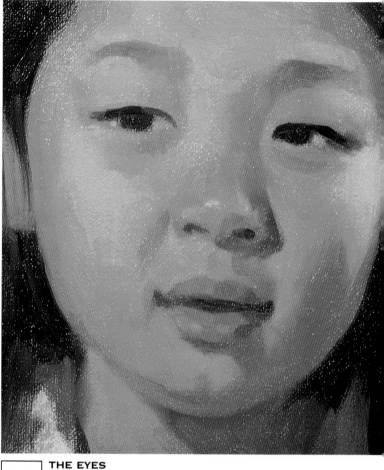

11 **THE LIGHTS**
Moving up, add halftones to the cheeks using a mixture of Burnt Sienna, Cadmium Red Light, Yellow Ochre and white. At this point, paint the side lighting on the model's left cheek with a mixture of white, Cadmium Red Light and Cadmium Yellow Light. For the light areas of the model's right cheek and forehead, a mixture of Cadmium Red Light, Yellow Ochre and white is used.

12 **THE EYES**
Use various mixtures of Cadmium Red Light, Raw Sienna and white to build the forms around the eyes. The dark irises are painted using a mixture of Burnt Umber and a touch of Cadmium Orange. Paint the upper lashes with solid Burnt Umber. A little Venetian Red is added to Burnt Umber for the upper lash nearest the nose on the model's right eye. The eyebrows are light, so paint them with a mixture of Burnt Sienna, Raw Umber and white.

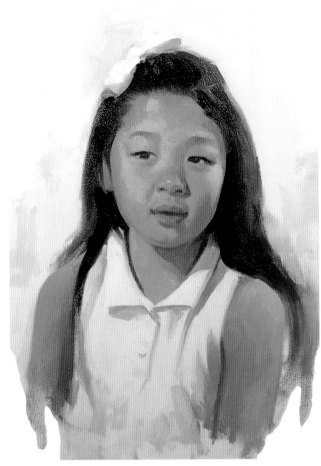

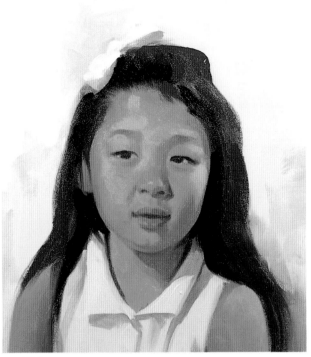

 14 **THE HALFTONES IN THE HAIR**
The next large shapes in the hair are warm halftones made up of Burnt Umber, Cadmium Orange and white.

13 **REDEFINING THE SHADOWS**
Moving down to the blouse, redefine this area with a mixture of white, Cadmium Yellow Light and a touch of Yellow Ochre. I decide to warm up the shadows with a mixture of Alizarin Crimson, Cerulean Blue, white and a touch of Burnt Umber. The large dark areas of the hair are redefined using a mixture of Burnt Umber and Ivory Black.

15 **THE HIGHLIGHTS**
Add the highlights next. Using a no. 8 filbert, paint on the mixture of white, Cadmium Yellow Light and Alizarin Crimson one stroke at a time. Make only one stroke on the canvas and then return the brush to your palette for fresh paint. More than one stroke will start to mix other colors on the canvas, ultimately turning to mud.

Once all the highlights have been applied, use a fan brush to blend the darks with the highlights. Clean the fan brush with turp between strokes.

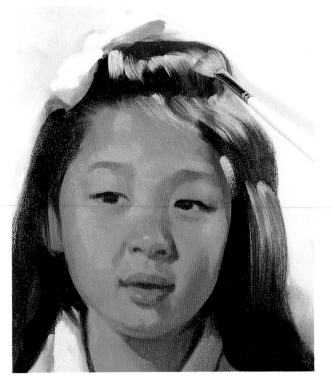

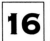

FINISHING UP

I try to see the bow as two shapes—dark and light. Start by painting the light shape with a mixture of white, Alizarin Crimson and Cerulean Blue. The dark shadows of the bow are brushed in with a mixture of Alizarin Crimson, Burnt Umber and white. The upper portions of each iris are in shadow from the upper lid. They are darkened with solid Burnt Umber. The mouth area needs more darks. Paint the space between the lips with a warm dark mixture of Burnt Umber and Cadmium Red Light. The shadow on the lower lip is also darkened with Cadmium Red Light, Raw Umber and white.

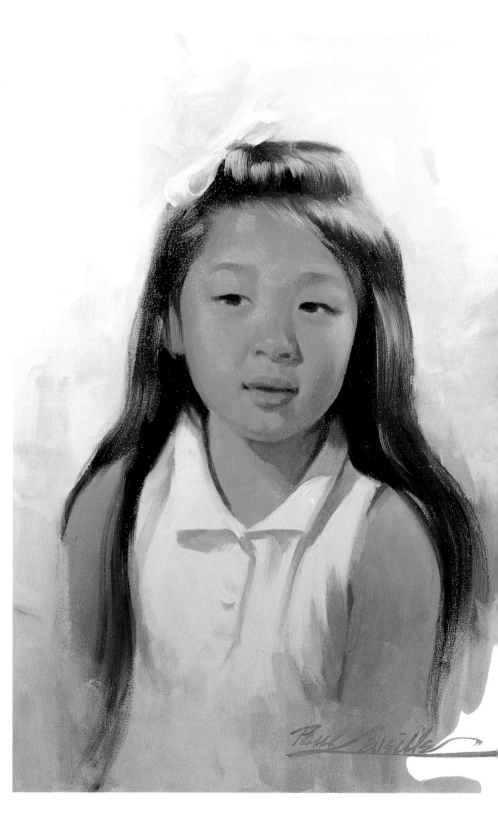

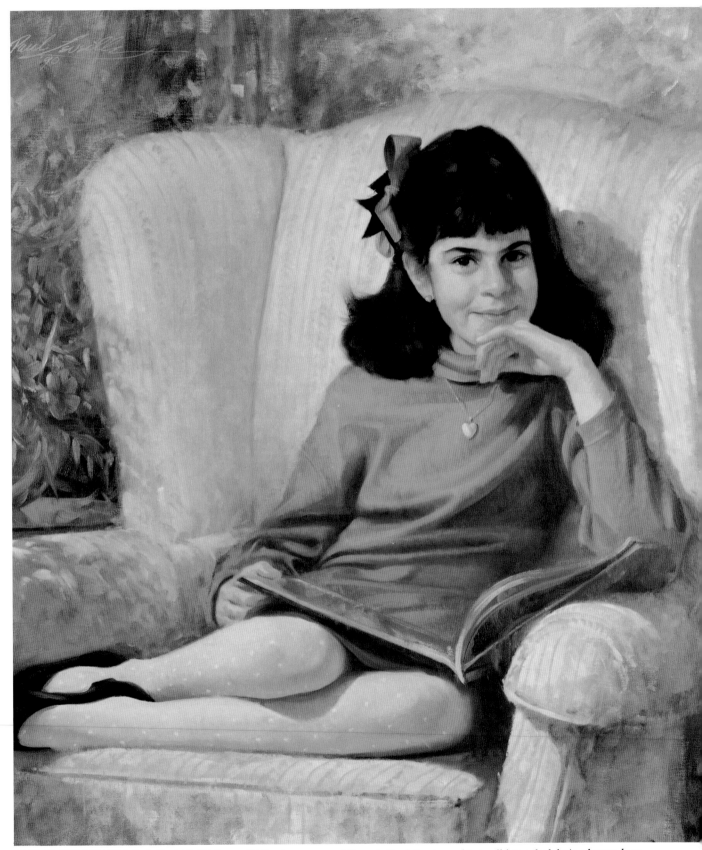

ELIZABETH LEVEILLE, 31" × 29" (78.7cm × 73.7cm)

Although the following subjects all have dark hair, observe how each child's complexion varies.

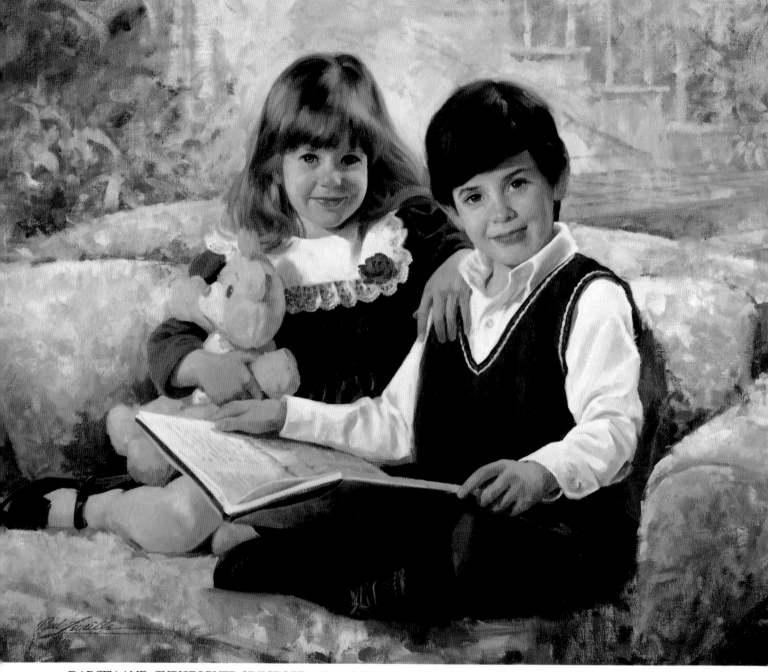

DARCEY AND CHRISTOPHER SINICROPE, *41" × 34" (104.1cm × 86.4cm)*

Once you feel confident painting the figure, try adding a more detailed, formalized background.

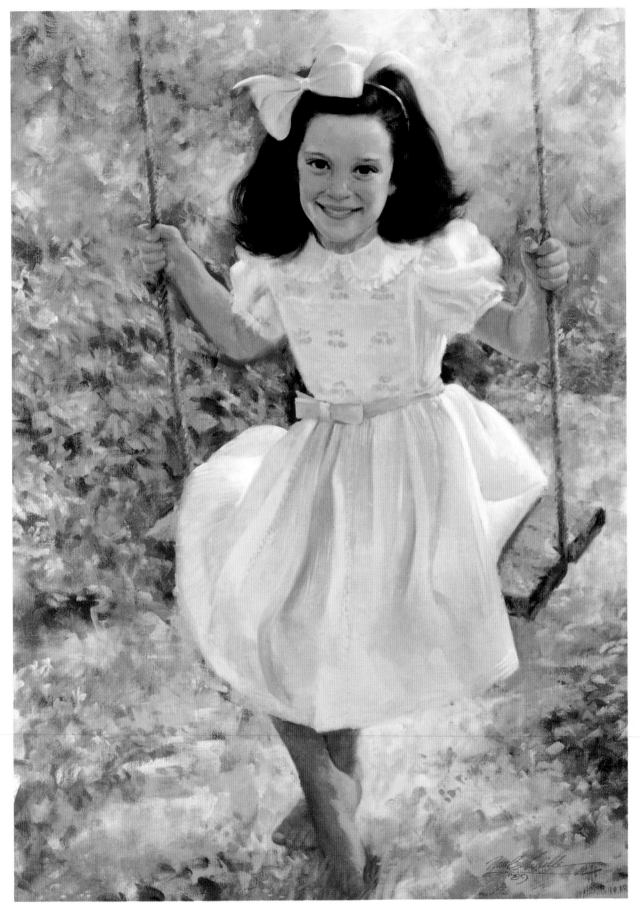

WHITNEY RICHEY, *28″ × 40″ (71.1cm × 101.6cm)*

INDEX

More Great Books for Oil Painters!

Your Painting Questions Answered From A to Z—Discover oil painting instruction at its finest! In her crystal-clear teaching style, renowned instructor Helen Van Wyk answers hundreds of the most-asked questions spanning her 40-year teaching career. #30933/ $16.95/198 pages/125 illus./paperback with vinyl cover

Oil Painting Step by Step—Master the medium of oils with this unique series of painting projects. Using this powerful teaching guide, you'll start with the foundational skills and work your way through more complicated techniques and lessons. #30879/$22.99/144 pages/300+ color illus./paperback

Fill Your Oil Paintings With Light & Color—Create vibrant, impressionistic paintings as you learn to capture light, color and mood in oils! Simple demonstrations help you learn the methods you need to create rich, powerful paintings. Plus, you'll find a showcase of finished works that's sure to inspire. #30867/$28.99/144 pages/166 color illus.

Creative Oil Painting: The Step-by-Step Guide and Showcase—Get an over-the-shoulder look at the diverse techniques of 15 master painters. You'll watch and learn as they use innovative methods and step-by-step projects to create gorgeous landscapes, still lifes and portraits. #30943/$29.99/144 pages/250 color illus.

First Steps Series: Painting Oils—Discover everything you need to know to start painting with oils right away—from tools and materials to how to put "the right color in the right spot." 12 step-by-step demonstrations and quick, easy "Painting Primer" exercises will have you creating your first still lifes and landscapes in no time at all! #30815/$18.99/128 pages/96 color illus./paperback

1997 Artist's & Graphic Designer's Market: Where & How to Sell Your Illustration, Fine Art, Graphic Design & Cartoons—Your library isn't complete without this thoroughly updated marketing tool for artists and graphic designers. The latest edition has 2,500 listings (and 600 are new!)—including such markets as greeting card companies, galleries, publishers and syndicates. You'll also find helpful advice on selling and showing your work from art and design professionals, plus listings of art reps, artists' organizations and much more! #10459/$24.99/712 pages

Oil Painting: Develop Your Natural Ability—Learn the building blocks that lead to excellent oil painting. You'll study 36 step-by-step exercises designed to take you through one important concept at a time—from creating preliminary sketches to evaluating your work objectively. #30818/$23.99/128 pages/ 220 color illus./paperback

Romantic Oil Painting Made Easy—Create sensitive, impressionistic paintings with guidance from internationally acclaimed oil painter Robert Hagan. No matter what your level of experience, you'll be able to create enchanting paintings almost immediately by using Hagan's unique "placement theory" and simple color system. #30894/$29.95/96 pages/400 color illus.

How to Get Started Selling Your Art—Turn your art into a satisfying and profitable career with this guide for artists who want to make a living from their work. You'll explore various sales venues—including inexpensive home exhibits, mall shows and galleries. Plus, you'll find valuable advice in the form of marketing strategies and success stories from other artists. #30814/$17.99/128 pages/paperback

Oil Painting: The Workshop Experience—Get all the benefits of the workshop experience without the inconvenience and expense of travel! With this unique workshop in print, you'll receive one-on-one instruction from artist Ted Goerschner as he shows you his secrets to fresh, bright color and techniques for painting outdoors. #30709/$28.99/144 pages/ 174 color, 13 b&w illus.

Becoming a Successful Artist—Turn your dreams of making a career from your art into reality! 21 successful painters—including Zoltan Szabo, Tom Hill, Charles Sovek and Nita Engle—share their stories and offer advice on everything from developing a unique style, to pricing work, to finding the right gallery. #30850/$24.99/144 pages/145 color illus./paperback

Capturing Light in Oils—Learn how to create dramatic landscapes filled with a strong sense of place and time of day. In addition to clear instruction, 13 step-by-step demonstrations show Strisik in action—using light, color and design to paint expressive landscapes. Plus, you'll explore the visual effects of light and how to use them to create dramatic effects in paintings. #30699/$27.99/144 pages/239 color illus.

100 Keys to Great Oil Painting—Find great advice on everything from selecting paints and brushes to harmonizing colors and displaying finished works. Plus, special sections offer advice on how to use oils to paint landscapes, portraits and cityscapes. #30728/$16.99/64 pages/color throughout

How to Capture Movement in Your Paintings—Add energy and excitement to your paintings with this valuable guide to the techniques you can use to give your artwork a sense of motion. Using helpful, step-by-step exercises, you'll master techniques such as dynamic composition and directional brushwork to convey movement in human, animal and landscape subjects. #30811/$27.99/144 pages/350+ color illus.

Painting the Beauty of Flowers With Oils—Create graceful florals using traditional, time-honored methods. Clear and friendly instruction covers everything from choosing subjects to painting troublesome parts of a still life. Step-by-step instructions show compositions in progress. #30666/$22.99/144 pages/195 color, 18 b&w illus./paperback

The North Light Artist's Guide to Materials & Techniques—Shop smart with this authoritative guide to buying and using art materials in today's most popular mediums—from watercolor, oil and acrylic to charcoal, egg tempera and mixed media. You'll find personal recommendations and advice from some of North Light's most popular artists, as well as informed discussions on basic techniques, shopping lists, paints, surfaces, brushes and more! #30813/$29.99/192 pages/230+ color illus.

Color Mixing The Van Wyk Way: A Manual for Oil Painters—Learn how to put color theory into action! You'll see how to paint any subject with the six basic colors plus white and gray. Van Wyk makes the frustrating task of color mixing easy to understand and put into action—even for the beginner! #30658/ $27.99/128 pages/230 color, 15 b&w illus.
